Masterpiece Photographs from the Minneapolis Institute of Arts

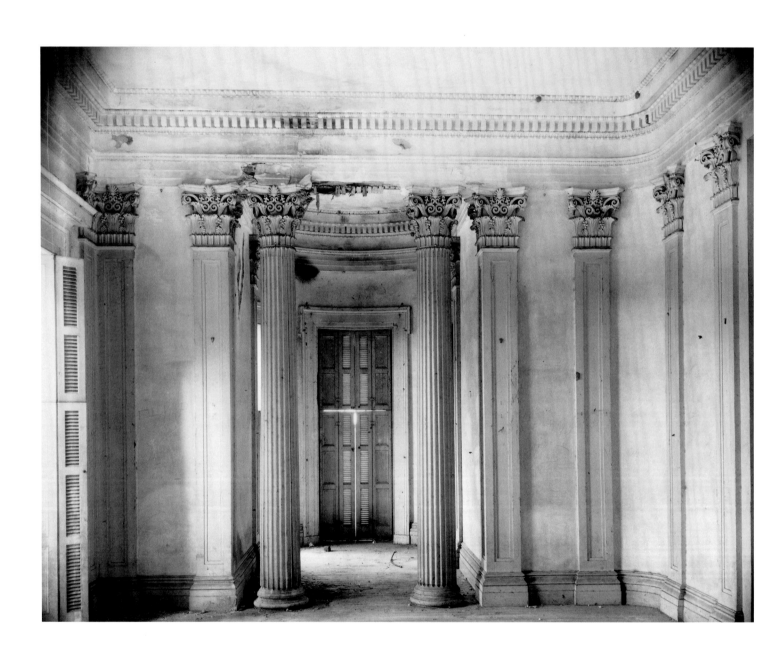

Masterpiece Photographs

from the Minneapolis Institute of Arts
The Curatorial Legacy of Carroll T. Hartwell

CHRISTIAN A. PETERSON

MINNEAPOLIS INSTITUTE OF ARTS

This book was published in conjunction with the
exhibition "Masterpiece Photographs from the Minneapolis
Institute of Arts: The Curatorial Legacy of Carroll T. Hartwell,"
October 4, 2008–January 25, 2009

Editor: Susan C. Jones
Designer: Sam Silvio
Photographer: Charges Walbridge
Publishing and Production Management:
Jim Bindas, Books & Projects LLC

Major support for this catalog and exhibition has been
provided by Alfred and Ingrid Harrison, Elisabeth J. Dayton,
Cy and Paula DeCosse through the Minneapolis Foundation,
Walt McCarthy and Clara Ueland, Frederick and Virginia Scheel,
Harry M. Drake, Martin and Lora Weinstein, and Myron
and Anita Kunin.

Minneapolis Institute of Arts
2400 Third Avenue South
Minneapolis, MN 55404
www.artsmia.org

Distributed by the University of Minnesota Press
111 Third Avenue South, Suite 290
Minneapolis, Minnesota 55401
www.upress.umn.edu

Library of Congress Cataloging-in-Publication Data

Peterson, Christian A.
 Masterpiece Photographs from the Minneapolis Institute
of Arts: the Curatorial Legacy of Carroll T. Hartwell/
Christian A. Peterson.
 p. cm.
 Published in conjunction with an exhibition held
October 4, 2008–January 25, 2009.
 Includes bibliographical references and index.
 ISBN 978-0-8166-5681-3 (hc: alk. paper)
1. Photography, Artistic–Exhibitions. 2. Minneapolis Institute of
Arts–Photograph collections–Exhibitions. 3. Photograph
collections–Minnesota–Minneapolis–Exhibitions. I. Hartwell,
Carroll T. II. Minneapolis Institute of Arts. III. Title.
 TR645.M542M5667 2008
 779.074776'579–dc22
 2008021865

COVER
Richard Avedon
Marilyn Monroe, Actor, New York, May 6, 1975

FRONTISPIECE
Walker Evans
Room in Belle Grove Plantation House, Louisiana, 1935

PRINTED IN SINGAPORE

Contents

Foreword

IN THIS BOOK, Christian A. Peterson, acting curator of photographs, presents and discusses fifty of the most notable and influential prints in the permanent collection of the Minneapolis Institute of Arts. The photographs selected for inclusion represent highlights of artistic achievement in both the history of photography and the museum's holdings.

Spanning nearly the entire 170 years of photography, this publication begins with an 1854 salt print by the English inventor William Henry Fox Talbot and ends with a 2002 color portrait by Minnesota's own Alec Soth.

In between are such iconic images as Edward Weston's *Pepper No. 30* (1930), Dorothea Lange's *Migrant Mother* (1936), and Ansel Adams's *Moonrise, Hernandez, New Mexico* (1941). Among other renowned photographers whose works are represented are Berenice Abbott, Diane Arbus, Eugène Atget, Richard Avedon, William Eggleston, Walker Evans, Robert Frank, Lee Friedlander, W. Eugene Smith, Alfred Stieglitz, and Paul Strand.

Carroll T. (Ted) Hartwell (1933–2007) founded the MIA's photography department and served as curator of photographs until his untimely death. Thanks to Hartwell's belief in the creative possibilities of the camera, the MIA was among the first American museums committed to representing photography as a fine art, one that merits the attention and respect accorded other creative media.

In 1964, Hartwell convinced the museum's then-director, Anthony M. Clark, to acquire a complete set of Alfred Stieglitz's seminal journal *Camera Work*. Hartwell continued to acquire significant work by both young Minnesota-based photographers and established masters such as Ansel Adams and Edward Weston. The MIA's collection is particularly rich in examples of documentary photography, photojournalism, and street photography, reflecting Hartwell's great passion for the humanistic approach. At the MIA, Hartwell's legacy now numbers some 10,000 photographs, a vast artistic resource available to the public through exhibitions, publications, loans, and other programs.

I would like to thank Christian Peterson, who worked with Hartwell for more than twenty-five years. He thoughtfully selected the objects for this publication and its accompanying exhibition, and wrote both the introduction and the succinct essays describing each image.

I would also like to thank the following donors who have made this catalog and exhibition possible: Alfred and Ingrid Lenz Harrison, Elisabeth J. Dayton, Cy and Paula DeCosse through the Minneapolis Foundation, Walt McCarthy and Clara Ueland, Frederick and Virginia Scheel, Harry M. Drake, Martin and Lora Weinstein, and Myron and Anita Kunin. Over many years, these generous individuals have supported our curators' vision, and have in their own way made significant contributions to the collection.

This project is a celebration of our collection of photographs and its founder. With it, we honor Ted Hartwell's pioneering and lasting contribution to the Minneapolis Institute of Arts, our community, and the art of photography.

KAYWIN FELDMAN
Director and President

Building the Collection and Presenting Exhibitions, 1963-2007

LIKE MOST OTHER AMERICAN ART MUSEUMS, the Minneapolis Institute of Arts paid modest attention to creative photography until the 1960s. Before that time, the MIA didn't collect photographs, deeming them unworthy of the permanent collection. It did, however, regularly host photographic exhibitions, presenting about one a year from 1932 to 1961. Most of these shows were created by other organizations and comprised populist imagery that appealed to the general public. During the 1930s and 1940s, for instance, the Minneapolis Camera Club presented an annual photographic salon that featured work by local and nationally known pictorialists— committed amateurs who created accessible, softly focused pictures. During the 1950s and early 1960s, the museum hosted traveling shows, such as one consisting of award winners in a national newspaper snapshot contest and another of classic portraits of famous people by Yosuf Karsh. "The Family of Man," a widely acclaimed exhibition organized by Edward Steichen, was a highlight of the MIA's 1955 schedule. This show, like many others seen at the museum, had a pervasively optimistic tone, and emphasized the subject matter of the pictures over the subjective creativity of the individual photographers.

In the fall of 1961, the museum presented, in its sales and rental gallery, a small exhibition of work by two Minneapolis photographers, one of whom was Carroll T. (Ted) Hartwell (figure 1). Unlike most previous photography shows, this one highlighted the artistic nature of each photographer's prints—in Hartwell's case, his take on contemporary Japanese culture. Ted had learned photography in the U. S. Marine Corps, worked as an aerial reconnaissance photographer over Korea and Japan, and at the time of the show, was making advertising and editorial photographs for a local commercial studio. In mid October, when the exhibition closed, Ted retrieved his photographs, and collected his share of the modest return generated by sales and rentals. He priced his pictures between ten and thirty dollars each. Then, in January 1962, less than six weeks later, the museum hired him as staff photographer, responsible for documenting the MIA's events and works of art. Although it wasn't obvious at the time, Ted's arrival would soon foster a new attitude about photography at this venerable institution, one that encouraged the presentation of challenging exhibitions of artistic work and the purchase of photographs for its permanent collection.

HARTWELL'S FIRST EXHIBITIONS

In 1963, during his second year on the job, Ted was responsible for photographing objects in the upcoming exhibition "Four Centuries of American Art," which would comprise more than 200 paintings and pieces of sculpture and decorative art. Noticing that no creative photographs were slated for inclusion in the show, he boldly suggested to the museum's director that he be allowed to organize an exhibition of American photographs to coincide with the larger show. To Ted's delight, the director agreed to his idea, thus granting the young photographer his first curatorial opportunity. In order to find outstanding original photographs for the show, Ted traveled to the few American museums that then had substantial collections of photographs: the Art Institute of Chicago; the George Eastman House, Rochester, New York; and the Metropolitan Museum of Art and the Museum of Modern Art, both in New York City. These four museums eventually lent more than 125 photographs for the exhibition "A Century of American Photography, 1860–1960," which opened in November 1963. Included was work by nineteenth-century photographers such as Thomas Eakins and Mathew Brady and pictorialists F. Holland Day, Gertrude Käsebier, and Clarence H. White. Among the photographers most

deeply represented were: Alfred Stieglitz (fifteen prints), Edward Weston (eight), and Walker Evans (eight). Contemporary photographers Harry Callahan, Paul Caponigro, and Aaron Siskind also contributed pictures.

This project was so successful that Ted was empowered to organize another major exhibition of photographs soon thereafter. "The Aesthetics of Photography: The Direct Approach," which opened in mid 1964, quite specifically focused on straight photography. A small selection of pictorial work was included for contrast, but the exhibition primarily featured pictures by Berenice Abbott, Ansel Adams, Eugène Atget, Henri Cartier-Bresson, Walker Evans, Robert Frank, Alfred Stieglitz, Paul Strand, and Edward Weston, each with ten prints or more. Ted also produced a modest catalog, in which he was identified as "Assistant Curator for Photography," although he still also was the staff photographer. He clarified the intent of his efforts this way: "The photographs in this exhibition exemplify a well-established, basic attitude about photographic vision. The term 'straight photography' is generally used, although 'direct,' as a word of description, is more explicit. . . . So far from being an old-fashioned or outmoded approach, straight photography is more than ever the core of the photographic tradition."

"The Aesthetics of Photography: The Direct Approach" was only Ted's second exhibition, but it essentially established his lifelong curatorial stance. For the next forty-four years, he would regularly feature the work of Abbott, Adams, Atget, Cartier-Bresson, Evans, Frank, Stieglitz, Strand, and Weston in both group and one-person exhibitions. Ted also purchased for the museum impressive numbers of photographs by many of these artists; he obtained, for example, more than seventy by Berenice Abbott, more than sixty by Ansel Adams, and nearly forty-five by Edward Weston. Straight photography is an expansive category that includes, most prominently, the genres of documentary, street photography, and photojournalism—none of which is mutually exclusive. With typical zeal, Ted pursued them all.

PICTORIAL PHOTOGRAPHY

Ironically, Ted's first photographic acquisition for the Minneapolis Institute of Arts was a body of work that contradicted the principles of straight photography. In 1964, shortly after "The Aesthetics of Photography: The Direct Approach" closed, he bought a complete set of *Camera Work*, Alfred Stieglitz's exquisite periodical of photogravures by American and European photographers. Published quarterly between 1903 and 1917, the magazine, with its lavish visuals and discerning articles, made this country's first convincing case for photography as fine art. Virtually all the imagery depended upon the soft-focus effects and accessible subject matter that was typical of pictorialism and anathema to the straight aesthetic. Prominent were images of nymphs by Anne W. Brigman, Barbizon-like landscapes by Robert Demachy, pictures of mothers and children by Gertrude Käsebier (figure 2), and misty portraits by Edward Steichen. At the time, it seemed as if the only way to create artistic photographs was to make them resemble paintings, drawings, and prints.

Despite his own aesthetic preferences, Ted accepted the style of the images in *Camera Work* because the periodical represented the beginnings of photography as an art form in this country and because Stieglitz and some of his colleagues had embraced straight photography by the 1910s. Throughout his career, Ted considered *Camera Work* the "cornerstone" of the museum's collection of photographs, both chronologically and philosophically. Early on, he spent untold hours poring over its pages, absorbing both the ideas in its articles and the emotions evoked by its images. He frequently included selections from *Camera Work* in rotating permanent-collection exhibitions at the museum and organized small shows of its gravures that traveled elsewhere. In his 1984 book *The Making of a Collection*, Ted recounted finding the set of *Camera Work* in a New York bookstore and commented upon the significance of acquiring it for the museum: "Here seemed to be Minneapolis's own modest version of the Stieglitz Collection, and I would enjoy it and its contents in much the same way as I had the Metropolitan's."

Ted acknowledged the role of pictorialism in the history of photography—as a necessary stepping-stone to his preferred direct approach. Not only did he include pictorial work in his first two exhibitions, but shortly thereafter, he also organized a three-person show from the Stieglitz collection of pictures by Alvin Langdon Coburn, Frank Eugene, and Joseph T. Keiley, pictorialists all. In 1977, he presented the traveling exhibition "California Pictorialism," one of the first to include work by the second generation of pictorialists who were active after World War I. Typical of Ted's tolerance was his willingness, over the course of the last twenty-five years, to let me, as a fellow curator in the department of photographs, organize

numerous exhibitions and acquire important examples of pictorial work. As a result, the MIA houses one of the country's most significant collections of pictorial photographs, comprised of a complete run of the journal *Camera Notes* (1897–1903) and large groups of pictures by William B. Post, D. J. Ruzicka, Adolf Fassbender, Max Thorek, Wellington Lee, and members of the Minneapolis Camera Club. *Camera Work* is included in this volume; the balance the museum's holdings of pictorial photographs will appear in a subsequent publication.

RICHARD AVEDON EXHIBITION

In 1970, Ted organized the most notable exhibition of his career—a large-scale, one-person retrospective of the photographs of Richard Avedon. For years, Avedon had commanded international acclaim and high fees for his innovative fashion pictures in *Harper's Bazaar* and *Vogue*. But Ted was more intrigued with Avedon's portraits, lesser-known personal work that had been published in a few deluxe books. He first proposed an exhibition to Avedon in 1966, but it took two more years and the added persuasion of the museum's director to win the photographer's agreement.

Presented during the summer of 1970, "Avedon" was a tour-de-force of riveting portraits displayed in seven prominent galleries (figure 3). The walls were painted silver and the ceilings black, creating an atmosphere that was simultaneously dazzling and accommodating to nearly 300 photographs. Many were portraits of prominent people from the arts, politics, and popular culture, including Pablo Picasso, Georgia O'Keeffe, President Dwight David Eisenhower, Governor George Wallace, Marilyn Monroe, and Ringo Starr, each starkly captured—in typical Avedon fashion—against a white background. Most of the images were made between 1946 and 1965, when Avedon had temporarily ceased doing personal work. The last gallery in the show, however, featured portraits he had made just months before of the Chicago Seven, who were on trial for their protests at the 1968 Democratic National Convention. These ten-foot-tall photographs, blown up larger than life size and nonchalantly tacked to the walls, were an unmistakable political statement about the tumultuous state of American culture at the time.

Accompanying the exhibition was a novel "catalog," devised, like the layout of the exhibition, by the innovative New York designer Marvin Israel. Contained within a silver folder that was blind-stamped "Avedon" were ten loose

reproductions, a large sheet of paper illustrating everything in the show, and a pamphlet with a short introduction by the photographer. Acknowledging the unaffected appearance of his pictures, Avedon stated: "I find passport pictures beautiful. When I was nineteen, I joined the Merchant Marine and worked in the photographic department. My job was to do identity photographs. I must have taken pictures of maybe one hundred thousand baffled faces before it even occurred to me I was becoming a photographer."

The exhibition was a phenomenal success. At the end of its two-month run, 34,911 people had seen it (almost 10 percent of the Minneapolis population then), averaging nearly 650 viewers a day. Even though the show didn't travel, it garnered attention in the national press, receiving reviews in the magazines *Modern Photography* and *Popular Photography*. Gene Thornton, art critic for the *New York Times*, described the gallery with the pictures of the Chicago Seven as "a brilliant coup de théâtre and a smashing close to a marvelous party." Avedon had presented a one-person exhibition of his fashion work at the Smithsonian Institution in 1962, but the Minneapolis show was his largest to date and the one that heralded his entrée into the art world. He was so pleased with the exhibition that shortly thereafter he issued a limited-edition portfolio of original photographs; the so-called *Minneapolis Portfolio* is included in this catalog.

DOCUMENTARY PHOTOGRAPHY

The passportlike nature of Avedon's portraits coincided with Ted's interest in the documentary approach. Documentary photographs in their most basic form merely capture the look of the objects placed in front of the lens and simply serve as visual evidence. Many documentary photographers, however, managed to observe their subjects with a more discerning eye, producing images that fulfilled their intended utilitarian purposes but with an artistic flare. In addition, many creative photographers adopted the documentary approach, infusing their work with a revealing sense of personal emotion.

The MIA's collection includes prints by nineteenth-century photographers whose commercial work surpassed that of their competitors. Felix Bonfils, who produced pictures of the Middle East for tourists on the Grand Tour, is represented by sixty photographs, and Georgio Sommer by two albums of Italian views. Work by such outstanding American topographical photographers as William Henry Jackson, Timothy H. O'Sullivan, and Andrew J. Russell

are in the MIA, as are more than eighty plates by Eadweard Muybridge from his extensive "Animal Locomotion" series.

The French photographer Eugène Atget, active around the turn of the twentieth century, is acknowledged as one of the finest documentarians. The MIA owns eight prints by Atget, one of which is included in this volume. Ted, believing visitors to the museum would appreciate seeing more of the master's work, booked all four of the traveling shows titled "The Work of Atget," circulated by the Museum of Modern Art in the mid 1980s. No museum outside of New York presented the full series of exhibitions, giving Twin Cities viewers rare access to about 400 photographs by Atget.

Berenice Abbott, one of America's leading documentary photographers, met Atget shortly before his death in 1927, while she lived in Paris. Inspired by Atget's systematic documentation of his native city, Abbott similarly photographed New York during the 1930s. Her crisp and dramatic images captured many landmark structures and venerable neighborhoods that have since disappeared. In 1971, Ted initially bought a few vintage prints of her New York scenes; subsequently, the museum acquired many large-scale prints of her most well-known images, including the iconic *New York at Night*. The MIA now owns more than seventy of her photographs, most of which were shown in a one-person exhibition in 2001.

In 1972 and 1974, Ted purchased more than fifty photographs by Lewis W. Hine, significantly bolstering the museum's collection of documentary work. Hine's incisive images of child-labor conditions appealed deeply to Ted as pioneering examples of the "concerned photographer." In the mid 1950s, Ted had studied at the University of Minnesota under Jerome Liebling, a leading exponent of documentary photography with a social conscience. He adopted Liebling's humanitarian sense for the medium, and over time, purchased several of his images and organized a one-person show of his work. The photographs of David L. Parker, who has captured child-labor conditions in many Third World countries, also reflect the influence of Lewis Hine. In 1999, the museum presented a two-person exhibition that paired his work with that of Hine. The MIA now owns more than 350 photographs by Parker, some of which depict the labor conditions of adults in Minnesota.

During the Great Depression, several U.S. government programs funded outstanding documentary work. Most significantly, the Farm Security Administration (F.S.A.)

hired numerous photographers to record the conditions of the poor, largely in the Deep South and West. Among such photographers represented in the museum's collection are Russell Lee, Dorothea Lange, Marion Palfi, Arthur Rothstein, and Marion Post Wolcott. Undoubtedly, the most important of those photographing the American condition during the 1930s was Walker Evans, one of the most prolific F.S.A. hires.

Evans's work is consistently authoritative, precise, and seemingly emotionally detached. It marks one of the high points in twentieth-century American photography and has been central to the photography program of the Minneapolis Institute of Arts. In the fall of 1974, Ted inaugurated the MIA's new photography gallery by presenting a traveling exhibition of Evans's work, organized by New York's Museum of Modern Art. Previously, most photography exhibitions were hung in a basement hallway outside the photo services studio/office, which Ted still ran (figure 4). When the museum reopened its doors in 1974, after a major two-year renovation and addition, a legitimate photography gallery debuted on the first floor. Simultaneously—and appropriately—Ted was relieved of his duties as staff photographer and became full-time curator of photographs.

Keenly aware of Evans's contribution to the medium, Ted soon began amassing his work for the museum's permanent collection. In 1975 and 1976, he acquired, by both gift and purchase, more than seventy-five examples, mostly vintage prints of key images. The MIA's holdings of Evans's photographs now exceeds 110, making our collection of his work one of the most significant in the country. The museum also hosted two subsequent Walker Evans exhibitions—one in 1977, drawn solely from the Chicago collection of Arnold H. Crane, and another in 2003, accompanied by a fully illustrated catalog of all the MIA's holdings of photographs by Evans.

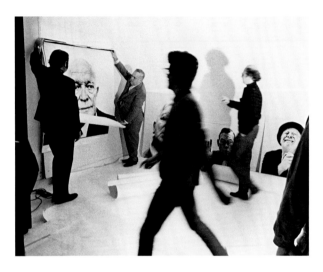

FIGURE 3
Installation of
"Avedon"
exhibition, 1970

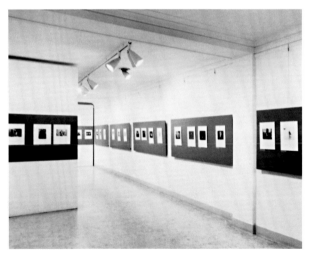

FIGURE 4
Photography
Gallery,
Minneapolis
Institute
of Arts, 1971

STREET PHOTOGRAPHY

Photographers began taking their cameras out onto urban streets early on, but the genre known as street photography wasn't recognized until the 1930s. By that time, small-format cameras and relatively light-sensitive roll film enabled photographers to work with available light and shoot quickly, sometimes literally "from the hip." As a consequence, many serious photographers began producing images that were immediate, gritty, and deceptively casual.

Ted paid attention to the so-called snapshot aesthetic of street photography from the beginning of his curatorial career. In his first two exhibitions, he included work by Robert Frank, its leading exponent. Frank had published his groundbreaking book *The Americans* just a few years earlier, and Ted understood the incisive nature of the imagery. Eventually, the museum acquired eighteen of Frank's photographs, most of which were reproduced in *The Americans*.

When Robert Frank turned to filmmaking in the 1960s, Lee Friedlander stepped to the forefront of street photography; for the past forty years, he has been extremely prolific and is now widely collected. The MIA has more than 100 of his photographs, many of them in portfolios and limited-edition books. Ted bought Friedlander's first portfolio, *Fifteen Photographs*, in 1973, the year it was published, and the museum has since presented three Friedlander exhibitions, beginning with one in 1976 that was drawn entirely from its own collection. A few years later, a traveling retrospective of his work was seen here, and in 1987, the MIA exhibited commissioned photographs that Friedlander had made at Cray Research, a computer company in nearby Chippewa Falls, Wisconsin.

Frank and Friedlander are only two of several notable contributors to the large cache of street photographs in the museum's permanent collection. Among the others are Diane Arbus (11 prints), Louis Faurer (22), Danny Lyon (120), Toby Old (120), Todd Papageorge (11), Garry Winogrand (105), and the Minnesotan Thomas F. Arndt (277). Reflective of these quantities is the fact that Ted gave Arndt, Lyon, and Old all one-person exhibitions.

PHOTOJOURNALISM

The last subset of straight photography that Ted championed and of which he sought examples was photojournalism. Photographs documenting current events and produced largely for publication form a significant portion of the MIA's permanent collection, as well as its exhibition record. In 1977, Ted was involved in the exhibition "Press Photography: Minnesota Since 1930," presented at the Walker Art Center. He helped cull through thousands of prints in local image "morgues" and wrote a catalog essay in which he revealed which photographers had personally inspired him: "My heroes were Alfred Eisenstaedt, Robert Capa, Werner Bischof, Henri Cartier-Bresson—all of them journalists. Whether they were artists did not seem to be a question. It was enough that these photographers, like W. Eugene Smith, had made it to the ranks of *Life* magazine, or were members of Magnum or Black Star [two agencies of photojournalists]. Such recognition and distinction held more significance for me than could any possible museum exhibition."

The museum has presented many exhibitions of photojournalists' work, revealing the great range of approaches and results within the genre. In the 1980s, for example, there were traveling shows of the magazine work of both Diane Arbus and W. Eugene Smith. The Arbus exhibition comprised her early, little-known work for *Esquire* and *Harper's Bazaar*, made before she began producing the unique portraits that became her hallmarks. The Smith show featured selections from many of the famous photo essays he produced for *Life*. In 1990, the MIA hosted "In Our Time: The World as Seen by Magnum Photographers," a large-scale exhibition of more than 300 memorable photographs. Organized to celebrate the fortieth anniversary of the world's premiere agency of photojournalists, it featured work by founders such as Henri Cartier-Bresson and Robert Capa and that of younger members like Susan Meiselas and Sebastião Salgado. The exhibition presented images of momentous historical events as well as poignant personal moments, from battlefield violence to tranquil human interaction. Ted had been the original curator on the project, having spent considerable time visiting Magnum members in New York, Paris, and elsewhere to review their life's work. The personal relationships he established with many of these individuals soon bore substantial fruit back in Minneapolis.

In the 1990s, Ted organized one-person exhibitions of two leading Magnum photographers. The first, in 1991, honored Gilles Peress, who had shot in Iran during the American hostage crisis in 1979–80. "Telex: Iran" comprised a nearly complete set of prints that were reproduced in a book of the same title and featured Peress's graphic, disjointed imagery of a country chafing at the imposition of radical Islam. Five years later, Ted, in conjunction with the museum's director, Evan Maurer, decided to show examples of all the media in which the only surviving founder of Magnum had worked for the last seventy years. Titled "Henri Cartier-Bresson: Pen, Brush, and Cameras," the exhibition included more than 125 drawings, paintings, photographs, and films, dating from 1924 to the present. This first such exhibition of Cartier-Bresson's work delighted the elderly artist for its comprehensiveness.

Continuing into the twenty-first century, Ted curated solo exhibitions of work by Werner Bischof and Marc Riboud, two other respected Magnum photographers. Bischof was one of the agency's earliest members, joining in 1949, only two years after it was established. Before his untimely death at age thirty-eight, he was extremely active, photographing in Korea, Japan, Indonesia, India, Mexico, and South America. For the exhibition, Ted drew from the extensive Bischof archive maintained by the photographer's son, choosing not only prints of his key images but also reproductions that maintained Bischof's work in the intended journalistic context of the printed page. The Marc Riboud show, one of Ted's last, opened in early 2006. It was dominated by Riboud's playful mid-century images of Parisian life, like his best-known image of a maintenance painter on the Eiffel Tower, and also included more recent color landscapes.

As Ted assiduously acquired examples of photojournalism for the museum's permanent collection, he usually purchased work directly from the photographers, as a means of supporting them. Not surprisingly, those he featured in one-person exhibitions are well represented: 38 photographs by Riboud, 60 by Cartier-Bresson, 86 by Bischoff, and an impressive 400 by Peress belong to the MIA. Those by Cartier-Bresson are primarily his masterworks, which measure a larger-than-usual size of fifteen by twenty-three inches. The MIA's major commitment to the work of Gilles Peress reflects the strength of his searing images and his prominence in the field of photojournalism. The museum owns large groups of his pictures from all his major projects, shot in Northern Ireland, Iran, Rwanda, and Bosnia. Significantly, we also have unique archival material, including maquettes and other preliminary items Peress used in producing his influential books *Telex: Iran* and *Farewell to Bosnia*. Other photojournalists whose work is in the museum's permanent collection are René Burri, Bruce Davidson, Robert Doisneau, Elliott Erwitt, Leonard Freed, Philip Jones Griffiths, William Klein, Mary Ellen Mark, James Nachtwey, Gordon Parks, Sylvia Plachy, Sebastião Salgado, David Seymour ("Chim"), Raghubir Singh, W. Eugene Smith, and Diana Walker.

MINNESOTA PHOTOGRAPHERS

In 1975, the Minneapolis Institute of Arts demonstrated its commitment to artists living and working within the state by establishing the Minnesota Artists Exhibition Program (MAEP), with a gallery devoted exclusively to Minnesota art. Photographers routinely serve on the selection panel, composed exclusively of artists, and regularly exhibit their work in the MAEP gallery.

Ted likewise organized both solo and group exhibitions that showcased the work of many Minnesota photographers in the museum's photography gallery. He was most involved in the local scene during the 1970s, when there was a groundswell of photographic activity here, supported by Film in the Cities, the University of Minnesota, and the Minneapolis College of Art and Design. Thanks to Ted's abiding interest in supporting homegrown talent, local photographers experienced their first solo exhibitions at the museum; Ramon J. Muxter and Stephanie B. Torbert were thus featured in 1970. The next year, Ted presented Richard Olsenius's documentary pictures of high-school life and Gary L. Hallman's large-scale, impressionistic images. Other Minnesota photographers who had one-person shows during the 1970s included James Henkel, Stuart D. Klipper, Linda Rossi, Allen Swerdlowe, and Robert Gene Wilcox.

In 1979, the MIA presented an exhibition organized by the Museum of Modern Art, New York, of grain-elevator pictures by Frank W. Gohlke, then Minnesota's most well-known photographer. Gohlke's work had been included the year before in a group exhibition at the museum titled "Minnesota Survey: Six Photographers"; others represented were Thomas F. Arndt, Mark Steenerson, Hallman, Klipper, and Torbert. This show was one of a series of similar exhibitions in various sites nationwide funded by the National Endowment for the Arts. Writing in the exhibition catalog, Ted explained that the purpose of the project was to show "America to Americans in a way that reveals some fundamental ideas and feelings characteristic of American experience. This exhibition is a continuation and reassessment of a fundamental tradition in picture-making orientation in American photography. The use of photography in the service of a broadly documentary manner is intrinsic to photography, historically, practically and philosophically."

Ted continued to showcase Minnesota photographers who used the camera to make straightforward pictures in the following decades. In 1984, for example, he presented "Tom Arndt's America," an exhibition of Minnesota's most prolific street photographer, and in 1992, Stuart Klipper's color work from polar regions was featured in a solo exhibition. Ted successfully lured back to Minnesota some photographers who had spent time in the state but no

longer lived here. One of these was Gus (Edward A.) Foster, who had served as the MIA's curator of prints and drawings during the mid 1970s; in 1993, his panoramic color landscape photographs were exhibited at the museum. Jerome Liebling was featured in a 1995 retrospective that included examples from his work on Minnesota politicians and a St. Paul slaughterhouse, produced while he taught photography at the University of Minnesota during the 1950s and 1960s. And in 2002, Ted organized a solo show of witty photographs of public events by Toby Old, who had grown up and practiced dentistry in Minnesota before moving to New York.

Even more impressive than the exhibition record of Minnesota photographers at the MIA are the museum's extensive holdings of work by those who still live here, many of whom enjoy national reputations. These include Bruce Charlesworth, Lynn Geesaman, Gary Hallman, James Henkel, Paul Shambroom, Alec Soth, Katherine Turczan, and JoAnn Verburg. Those represented by 100 or more photographs are Tom Arndt, Wing Young Huie, Stuart Klipper, David Parker, and Robert Wilcox. The Wilcox collection is unique for the museum, as it includes the vast majority of the photographer's prints, negatives, and films, produced before his untimely death in 1970 and representing a key element in the Minnesota documentary tradition.

THE COLLECTION'S MASTERPIECES

The permanent collection of the Minneapolis Institute of Arts now numbers about 10,000 photographs, primarily twentieth-century American work. Examples of documentary photography, street photography, and photojournalism understandably dominate this book, reflecting Ted's preferences. Any selection of images is, of course, arbitrary—whether for exhibition, acquisition, or publication—and this one is, of necessity, mine. After Ted's death in July 2007, the museum decided to honor his long legacy as a curator with an exhibition of masterpieces from the collection, accompanied by this publication. Needless to say, if Ted had made the selection, it would have been different. I chose the fifty photographs reproduced here for their singular importance to both the MIA's collection and the history of photography as a whole. Simply put, I was looking for vintage prints of key images that are

particularly, as Ted would say, "salient." While it was easy to select some of these, such as Edward Weston's *Pepper No. 30,* I thought long and hard before choosing others, such as pictures by the lesser-known photographers Val Telberg and Consuelo Kanaga. It is my strong belief, however, that every picture stands on its own merits and that together they function as a cohesive whole. Fortunately, the scope of our holdings allowed me to represent virtually the entire chronology of the medium, from its origin in the mid-nineteenth century to the present. At the beginning of the book is a calotype by inventor William Henry Fox Talbot and at the end a color portrait by the prominent contemporary photographer Alec Soth, a Minneapolis native who worked for more than five years in the museum's photo services department—where Ted's MIA career also began. In between are late-nineteenth-century topographical images by Francis Frith and others, modernist compositions by the likes of Czech photographer Jaromír Funke, a William Eggleston study of the mundane, and recent challenging work by Joel-Peter Witkin. To acknowledge both their importance to our collection and Ted's aesthetic preferences, Walker Evans and Robert Frank are the only photographers accorded two pictures each. In a few cases, I have allowed one image to stand for a seminal body of work, such as portfolios by Richard Avedon and Diane Arbus.

Ted originally wanted to include small reproductions of all the museum's photographs—then some 2,500—in his 1984 book, *The Making of a Collection.* I repeatedly witnessed such zealous enthusiasm when he was selecting photographs for exhibitions; he almost invariably chose more than could comfortably fit into our gallery. Similarly driven, he began contemplating an update to the book only a few years after its publication, wanting again to share as many of our holdings as possible with a burgeoning audience for fine photography. Unfortunately, Ted's updated version was never realized. But because most of the pictures included here were acquired after the publication of *The Making of a Collection,* I like to think the book you're holding would meet with his approval. In any case, *Masterpiece Photographs from the Minneapolis Institute of Arts* represents my best effort at thanking Carroll T. Hartwell for the privilege of working with him for more than twenty-five years.

Plates

William Henry Fox Talbot

THIS IMAGE shows Reverend Calvert R. Jones, Jr., seated in the sacristy of Lacock Abbey, the home of William Henry Fox Talbot. Jones was a friend of Talbot and a photographer in his own right, using both the daguerreotype and calotype processes in Italy, England, and his native Wales. Dressed in a towering top hat appropriate to his upper-class status, he casually positions himself at the edge of an arched opening in order to catch the midday September sun.

Much of this portion of Lacock Abbey was covered with vines, providing a dark, organic sheath to the ancient architecture. Talbot frequently turned his camera on his expansive residence, photographing its latticed windows, stately rooms, and fortresslike exterior. Lacock Abbey was founded as a convent in 1232 and bought by a member of Talbot's family in the sixteenth century. It was a peaceful country estate, set outside the Wiltshire village of Lacock, among the rolling hills of the River Avon valley. Talbot began living there when he was twenty-seven years old and remained for the rest of his life.

In 1839, Talbot revealed his invention of the negative/positive process of image making; it would remain the basis of photography for the next 150 years. He began experimenting with light-sensitive materials in 1834, after being frustrated by his inability to draw. Initially, he made photograms—images generated by placing objects on light-sensitive paper and exposing them to light. Soon, however, he was using a camera to make paper negatives, which he then contact printed to render a positive image.

The calotype (also called talbotype and sun picture) produced soft images, due to the paper fibers in the negative. This characteristic and the fact that Talbot patented his process limited its adoption by others. The inventor, however, used it extensively during the 1840s, establishing a business to print photographs in quantity and illustrating books with original calotypes. Between 1844 and 1846, he issued six installments of printed text and photographic prints. Bound together, they became the first photographically illustrated book—*The Pencil of Nature*. This milestone in both publishing and photography comprised twenty-four images of such prosaic subjects as a ladder, glassware, and books, rendered with naïve simplicity.

Cloisters of Lacock Abbey was purchased in 1974 from Graphics International Limited, Washington, D.C., which had acquired it from heirs of Talbot. The "LA" notation on the back is a Lacock Abbey number, assigned in the 1950s by Harold White, who performed an inventory of the estate's holdings. This calotype is one of three by Talbot that the museum owns.

William Henry Fox Talbot, English, 1800–77
Cloisters of Lacock Abbey, 1845, calotype
6 1/2 x 8 1/16 inches (image), 7 5/8 x 9 3/4 inches (sheet)
"LA 295," in ink, verso
John R. Van Derlip Fund, 74.12

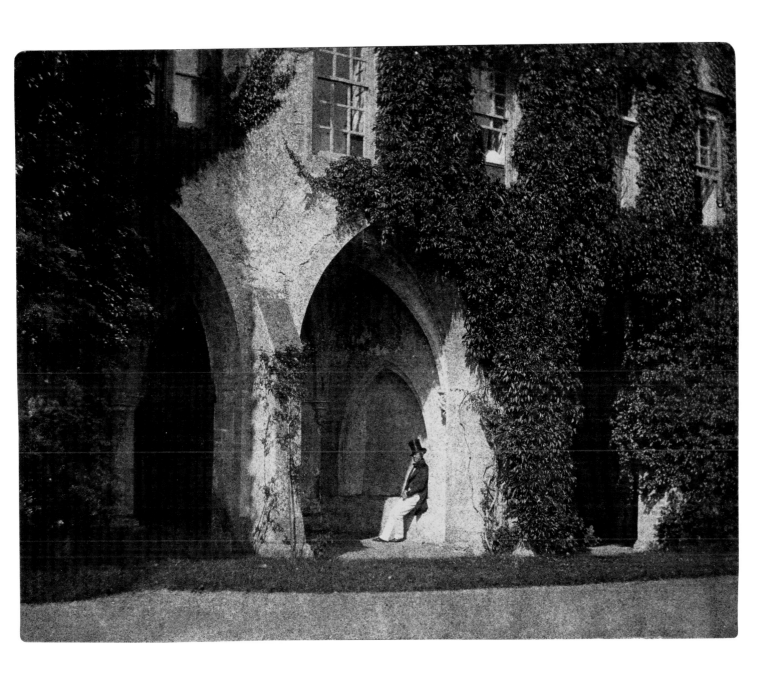

Anna Atkins

IN THE 1840S AND 1850S, Anna Atkins produced elegant images from nature, such as this one of an unidentified fern from New Zealand. In it she effectively used the specimen to tease the right edge and upper corner of the picture with the pointed ends of leaves. The gentle curve of the stalk and the repetitive shape of each branch suggest human vertebrae and the harmony of the natural world. While most of the fern is rendered in crisp outlines, portions of it are muted, giving the image a ghostlike quality. Atkins made the image without using a camera; instead, she placed the fern directly on a sheet of light-sensitive paper that she then exposed to light and developed.

Anna Atkins was an amateur botanist who avidly collected natural specimens in England and solicited examples from others elsewhere. Inspired by the inventor William Henry Fox Talbot, a family friend and close contemporary, she became the world's first woman photographer. In 1843, she issued multiple copies of an album of "cyanotype impressions" of British algae, the first significant use of scientific photography in published form. Atkins printed all her images as cyanotypes, a simple process most frequently used by architects for blueprints. The vibrant hue of *New Zealand* reflects Atkins's preference for the medium's vivid blue tonalities to the brown color common to most other nineteenth-century photographic papers.

This picture was purchased in 2006 from Hans P. Krause, Jr., New York. It came from the unique album *Cyanotypes of British and Foreign Flowering Plants and Ferns*, which Atkins presented to a friend in 1854. Containing 160 plates, it was sold at a London auction in 1981 and then split up. This is the only print by Atkins in the permanent collection of the MIA.

Anna Atkins, English, 1799–1871
New Zealand, c. 1853, cyanotype
13 7/8 x 9 7/8 inches (image and sheet),
19 1/16 x 14 3/4 inches (mount)
"New Zealand" in negative
William Hood Dunwoody Fund, 2006.10

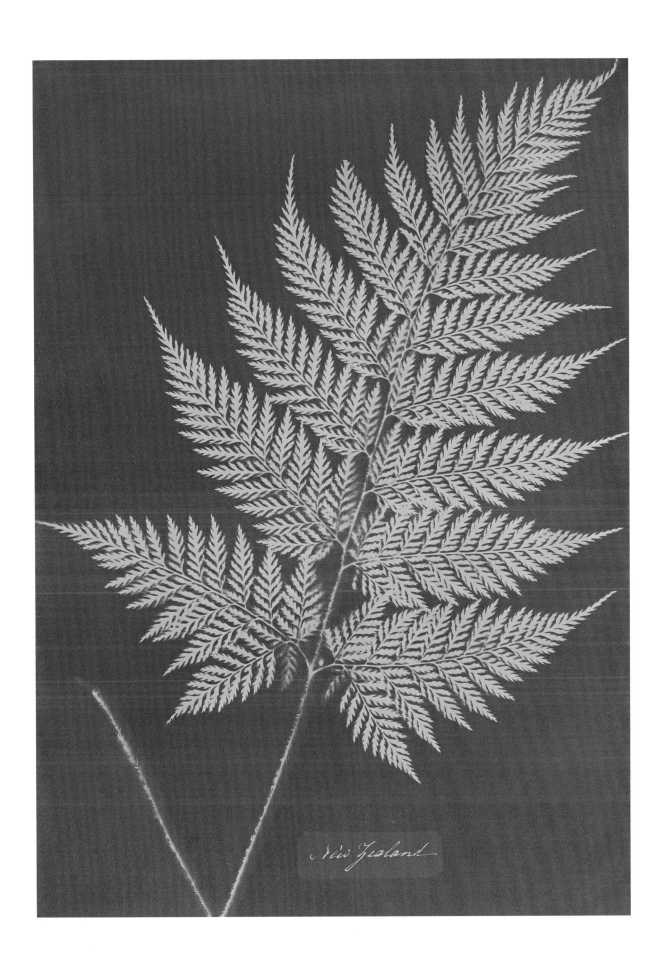

Jeremiah Gurney

THIS CONFIDENT PORTRAIT of a handsome young man reveals the strengths of the New York portrait photographer Jeremiah Gurney. Typical of Gurney's daguerreotypes of men, this one shows the unknown subject without any props, against a neutral background, and sensitively side-lit. The well-dressed and coiffed figure gazes directly into the lens and is presented from the lower chest up, in classic three-quarter view. Gurney allows the man's head to loom large in the frame, indicating a strong personality, and avoids including the subject's hands, suggesting a profession reliant upon his intellect. Gurney made this realistic portrait between 1852 and 1858, when his New York studio was located at 349 Broadway, six blocks north of City Hall.

In 1839, the Frenchman Louis-Jacques-Mandé Daguerre announced to the world one of the first two processes for making photographic images. A daguerreotype is a silver-coated copper plate (made light sensitive by fuming with iodine) that is developed by mercury vapors after exposure in the camera. Every daguerreotype is unique because no negative is involved, and is characterized by meticulous detail and a highly reflective surface.

The process was quickly adopted throughout Europe and the United States, and was used almost exclusively for portraiture.

Gurney opened his first daguerreotype studio in 1840, on New York's prestigious Broadway Avenue. His main competitor was Mathew Brady, who remains more well known today, but by 1853, Gurney was the nation's premier portrait photographer; that year, he won the Anthony Pitcher, the first and most coveted American prize ever awarded for daguerreotypes. He ran studios at various New York locations for some fifty years, closing his last one in 1890. During that span, he outperformed all his colleagues in both the quality of his images and the longevity of his enterprise. He made pictures in every major nineteenth-century photographic medium and format, including *cartes de visite,* cabinet cards, and stereocards.

Virginia P. Moe gave the museum this daguerreotype in 1981. Seven years later, the MIA purchased her entire collection of Gurney objects, comprising nearly 300 photographs on paper, 70 daguerreotypes, and pieces of ephemera. These holdings represent the major archive of Jeremiah Gurney material.

Jeremiah Gurney, American, 1812–95
Untitled, 1852–58, daguerreotype (half plate)
4 9/16 x 3 1/2 inches (oval)
"J. Gurney" and "349 Broadway" stamped into the metal mat
Gift of Virginia P. Moe, 81.121

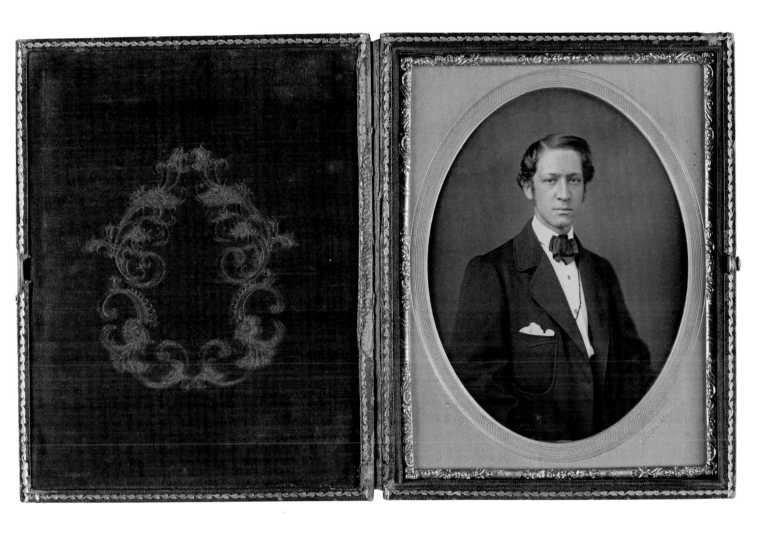

Gustave Le Gray

GUSTAVE LE GRAY is best known for three bodies of work: dramatically lit seascapes, forested landscapes inspired by Barbizon paintings, and ethereal documents of Napoleon's military camp outside Paris. Among his approximately thirty pictures of the sea, *Brig on the Water* is the most iconic. Its intense lighting, disproportionate ratio of sky to water, and silhouetted forms combine to make a singular nineteenth-century masterpiece. The picture was so popular in its time that the photographer reportedly sold 800 prints of it in 1856 alone.

Brig on the Water features a theatrical skyscape, with billowing cumulous clouds. Le Gray purposely chose a moment when a few large clouds shielded the sun, creating strong back lighting on some clouds and gentle illumination on others; this *contre-jour* effect almost suggests a moonlit scene. Blinding light reflects off a small portion of the water, while everything else below the crisp horizon line is dark and calm. Only a few sails on the brig, a two-masted ship with square rigging, are deployed, so the vessel is captured at rest, boldly silhouetted against the water. In order to frame the image and focus attention on the brig, Le Gray printed the edges of the photograph darker. Many other prints of *Brig on the Water* include a sliver of shoreline with another boat and horse cart along the bottom, elements that distract from the primary subject.

Le Gray, like other early outdoor photographers, faced the technical challenge of capturing correct tonalities in both the sky and the area below it. Exposing correctly for the sky usually rendered objects below the horizon too dark, and exposing for the latter generally produced a blank sky. Consequently, most landscape photographers printed in clouds from a stock of negatives made for that purpose. Le Gray, however, developed working methods and chemistry, the details of which he never revealed, that usually allowed him to capture everything on a single negative, as he apparently did here.

Le Gray studied painting with Paul Delaroche, and exhibited in the Paris salon. By 1850, he had learned photography and began writing about its technical and aesthetic aspects. The lavish professional studio he operated in Paris from 1856 to 1860 became a meeting place for painters, photographers, and writers, including Charles Baudelaire. In 1861, he abandoned his family and traveled to the Middle East; he died a year later in Egypt.

Brig on the Water is the only print by Le Gray in the MIA's permanent collection. Its provenance is: John Chandler Bancroft (Middleton, Rhode Island), to a New England antiques dealer, to the Lee Gallery (Winchester, Massachusetts), to dealer Stephen T. Rose (Indianapolis).

Gustave Le Gray, French, 1820–62
Brig on the Water, 1856, salt print
10 1/8 x 14 15/16 inches (image and sheet),
 20 1/4 x 25 15/16 inches (mount)
No inscriptions
Alfred and Ingrid Lenz Harrison Fund, 93.21

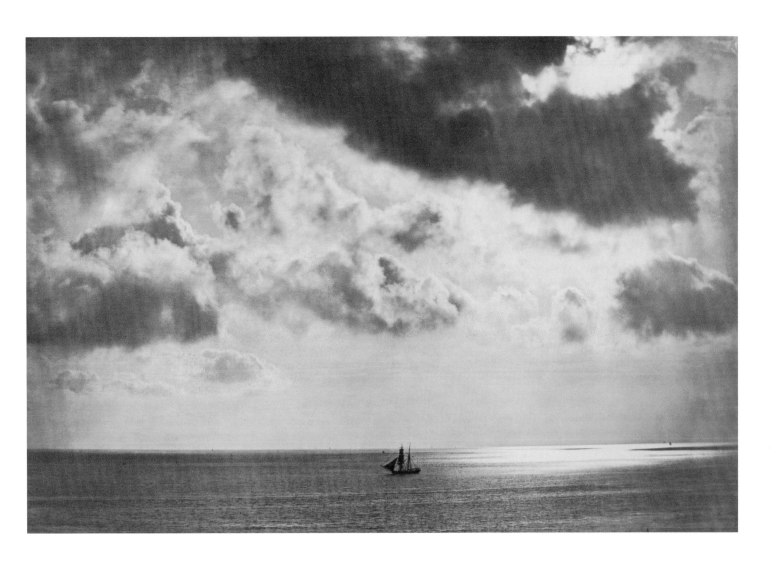

Francis Frith

IN THIS IMAGE, Francis Frith captures Egypt's most celebrated ancient monuments, the great pyramid and sphinx of Giza, located five miles west of Cairo. The pyramid of Cheops is the largest of three pyramids there, all built during the Fourth Dynasty (2545–2457 B.C.); it measures nearly 500 feet from base to apex and comprises more than 2 million blocks, each weighing about two and a half tons. Next to it is the great sphinx, built by Pharaoh Khafra after the completion of his own pyramid. This enigmatic form features a winged lion with the bearded head of the sun god. By the time Frith photographed it, in 1858, the effects of sand abrasion and target practice by unruly soldiers had worn away many of its features.

Frith emphasizes the monumentality of his subjects by presenting them as the only solid structures in a sea of undulating sand. The sphinx is presented in sharp profile and with deep shadows formed by back lighting. A feature-less sky highlights the pyramid's simple geometry. To emphasize the enormity of the monuments, the photographer included four figures and a donkey, which appear as only tiny, dark blobs. Rich shadow areas and creamy highlights in this large albumen print demonstrate Frith's technical skills.

Frith was the first notable foreign photographer to visit Egypt, making three trips there in the late 1850s. He photographed with a stereo, a medium-format, and a mammoth sixteen-by-twenty-inch camera, making wet-collodian negatives; this process—especially challenging in the heat and dust of the desert—required sensitization and development on the spot. His original prints subsequently appeared in several books and portfolios, accompanied by his own text. In 1860, Frith established a company that printed postcards and original photographs of England, Europe, and the Middle East. Francis Frith and Company, which became one of the world's largest photographic publishers, finally closed its doors in 1971.

The Great Pyramid and the Great Sphinx, Egypt was purchased in 2004 from the Weinstein Gallery, Minneapolis, which acquired it from the Edwynn Houk Gallery, New York. The MIA owns seven other photographs by Frith, most of them also picturing Egypt.

Francis Frith, English, 1822–98
The Great Pyramid and the Great Sphinx, Egypt, 1858, albumen print
15 7/16 x 19 1/2 inches (image and sheet), 21 1/4 x 28 7/8 inches (mount)
Printed on the mount: "The Great Pyramid, and the Great Sphynx" [*sic*]
 and "Frith: Photo. 1857" [*sic*]. "Frith 1858" in the negative
Alfred and Ingrid Lenz Harrison Fund, 2004.24

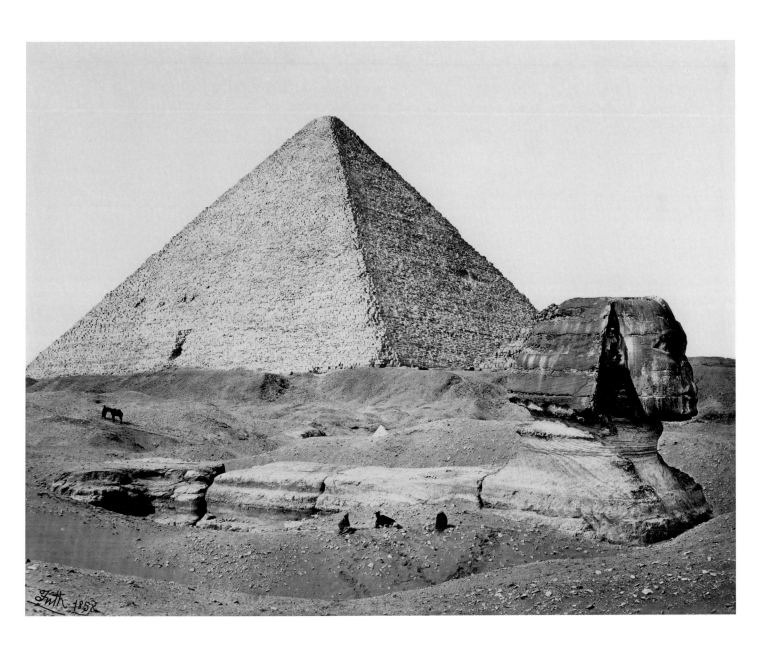

Carleton E. Watkins

IN THE 1860S, it took twenty-four hours to travel by stagecoach from San Francisco to Yosemite Valley, a vast, thousand-square-mile tract of largely unexplored land. Two of the area's most remarkable mountains were North Dome and Half Dome, the latter of which resulted from a massive geological collapse centuries ago.

Ostensibly, the Domes were the subject of this image by Carleton E. Watkins, who spent considerable time photographing both on the floor of the valley and from the mountain peaks. But because Watkins shrouded the domes in so much atmospheric haze and placed them at such a distance, the foreground elements became his true subject. A stream, its bank, and trees fill up the frame and assume a grandeur all their own. Here, Watkins carefully orchestrated reflections, detailed imagery, and contrasting values into a vision of harmonious and ordered nature. Perhaps his most effective juxtaposition was that of the silky smooth water and the heavily textured shore of pebbles beyond it.

Watkins's immense wooden camera yielded large negatives, which he then printed in direct contact (not by enlargement) with photographic paper. Prints measuring sixteen by twenty inches (like this one) or bigger were referred to as mammoth plates and were distinguished by the kind of meticulous detail visible here. Watkins printed *Distant View of the Domes* on albumen paper, which was made with egg whites and was the most widely used photographic paper of the late nineteenth century.

He took full advantage of the paper's wide range of tones, from brilliant highlights to deep shadow areas.

Watkins enjoyed a fifty-year career in photography, beginning in about 1855, when he apprenticed with the California daguerreotypist Robert Vance. He first photographed in Yosemite Valley in 1861, using both a mammoth-plate camera and a smaller one for making popular stereo views. From his San Francisco studio, which he called the Yosemite Gallery, he sold landscape views that helped convince the United States Congress to enact preservation legislation for the valley. In 1865, Mount Watkins was named after him, in recognition of his contributions to the California State Geological Survey. In addition to Yosemite, Watkins photographed Oregon's Columbia River and the landscape, estates, and mining towns of numerous western states. In 1875, due to personal financial problems and a national economic slowdown, Watkins lost his gallery and all his negatives to Isaiah West Taber, a competing photographer. Subsequently, he returned to many of his most revered California subjects to rebuild his stock of negatives. Watkins's eyesight and health were failing by the turn of the twentieth century. In 1906, when the San Francisco earthquake and fire completely destroyed his studio, he was forced to retire at age seventy-seven.

Distant View of the Domes, Yosemite Valley, California was given to the MIA in 1991 by Walter R. McCarthy, about ten years after he bought it. The museum owns two other landscapes by Watkins.

Carleton E. Watkins, American, 1829–1916
Distant View of the Domes, Yosemite Valley, California, c. 1866
Albumen print (1875 or later)
15 3/4 x 20 7/16 inches (image, sheet, and mount)
Title and the number "58" typeset in the negative, lower left;
 narrow top portion of Taber's credit in the negative, lower right
Gift of Walter R. McCarthy, 91.125

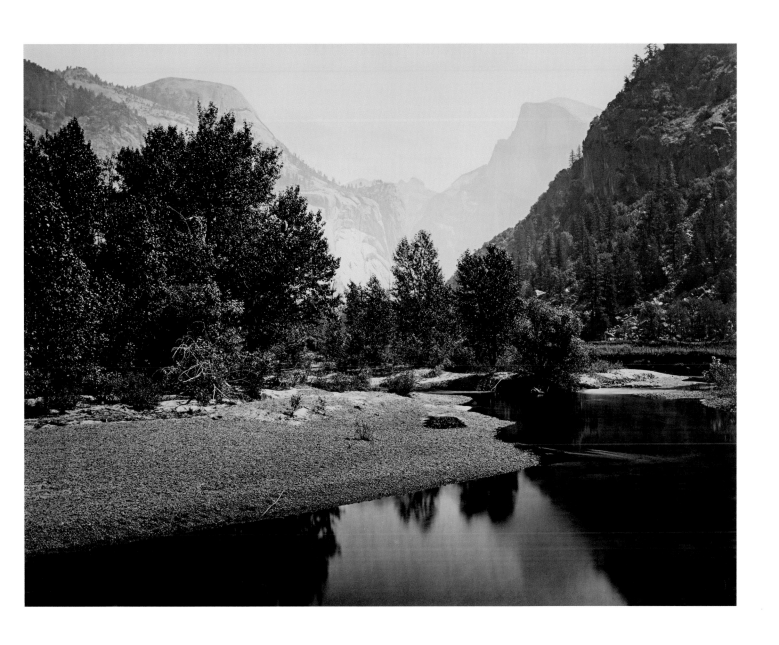

Henry P. Bosse

THIS IMAGE depicts a graceful curve in the Mississippi River just north of Hastings, Minnesota, looking upriver and northwest toward Inver Grove Heights. Because the course of the river has changed so much since Bosse photographed the scene, it is impossible to determine the exact vantage point, but apparently he was situated on an overlook near Spring Lake. Visible in the photograph are numerous wing dams, built perpendicular to the banks of the river and now submerged. The natural material (rocks), slender design, and uneven spacing of these man-made dams make them appear integral to the river's shape.

Henry P. Bosse was unknown to present-day historians until the early 1990s, when a few albums of his photographs of the upper Mississippi were discovered. The album from which this print came originally belonged to Major Alexander MacKenzie, regional commander of the U.S. Army Corps of Engineers at the end of the nineteenth century. MacKenzie oversaw the Corps's first major navigational improvement of the upper Mississippi: maintaining the river at a minimum depth so steamboats could travel between St. Louis and Minneapolis. In 1883, he asked Bosse, his chief draftsman, to photograph the decade-long project. Working out of Rock Island, Illinois, Bosse used his camera to document the character of the river and its towns and to capture the efforts of the Corps to shape and reroute the mighty Mississippi.

Bosse printed this and most of his other photographs as cyanotypes, blue images yielded through a simple process. The cyanotype incorporates iron, instead of silver, as the light-sensitive compound, and is developed in plain water. In printing this photograph as an oval, Bosse imparted a painterly appearance and a pictorial coherence to the image.

Pine Bend, Minnesota was purchased in 1995 from the Minneapolis dealer Christopher Cardozo. It is one of five cyanotypes by Bosse in the MIA's collection.

Henry P. Bosse, American (born Germany), 1844–1903
Pine Bend, Minnesota, 1891, cyanotype
10 3/8 x 13 inches (oval image), 14 3/8 x 17 1/8 inches (sheet)
Title and date, in ink, below image
Alfred and Ingrid Lenz Harrison Fund, 95.2

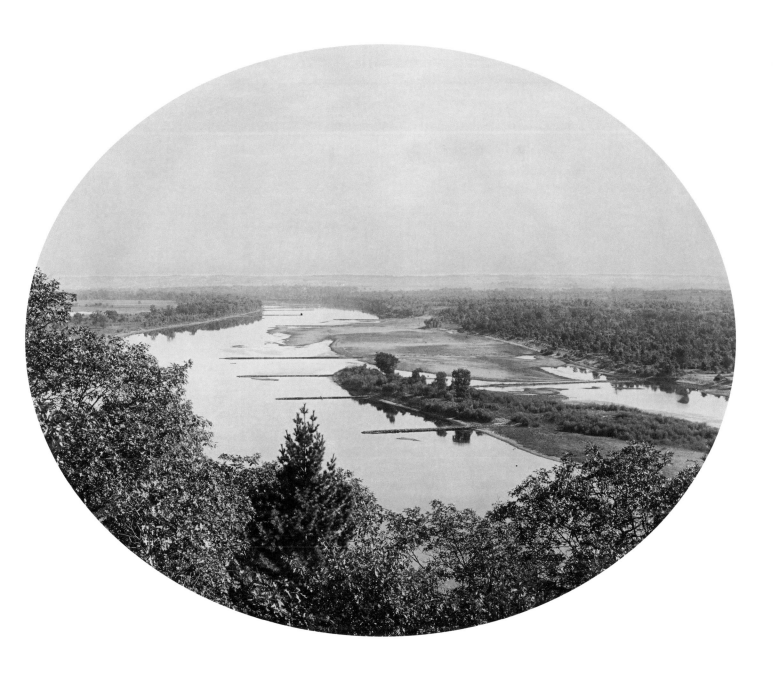

Jean-Eugène-Auguste Atget

BY THE END of the nineteenth century, France had enjoyed a long tradition of artists depicting street vendors and tradespeople. Referred to as *petits métiers,* they were rendered, often playfully, by Honoré Daumier and other painters and printmakers. From 1899 to 1901, Eugène Atget undertook his own such series, photographing individuals selling baguettes, peddling flowers, or offering services like window washing. A few years later, a Parisian publisher issued a set of eighty postcards reproducing these photographs.

This image shows a moustached fellow peddling lampshades on a cobblestone street. As in Atget's other vendor portraits, the subject looks off camera, a gaze that tends to remove the photographer from the equation. This picture, however, differs from virtually all the others in the series in its use of deep focus, from the foreground to the far distance. While Atget isolates his other subjects by casting their surroundings out of focus, here he provides the context of a particular spot in Montmartre by showing details of the street, sidewalk, and buildings.

The cobblestones receding into the background are, for example, particularly noticeable. Their uniform pattern contrasts with the variously decorated and colored lampshades the seller holds in his hands and carries in his basket. Note that the man's hat, neatly silhouetted against the sky, mimics the shape of a shade. Even though the subject appears to have been alone on the street, ghost images near the end of the sidewalk suggest otherwise. Atget used a wide-angle lens to achieve the exaggerated perspective of the image. Objects close to such a lens appear somewhat elongated or pulled toward the edges of the image, as is the case with the man's right foot, which seems to be viewed from above. Likewise with the lampshades to the left, which appear ready to fly from the vendor's basket.

Atget is known for his extensive documentation of Paris and its environs, working from about 1890 into the 1920s. In addition to city streets and architecture, he photographed tradespeople and prostitutes. He first advertised his photographs as "documents for artists," and Maurice Utrillo is among the painters known to have worked from his pictures. Around 1900, he began selling many of his photographs to government institutions, such as the Musée Carnavalet and Bibliothèque Nationale. Around the time he made this photograph, he moved to 17 bis, rue Campagne-Première, where he resided for the rest of his life. He did not photograph during World War I, due to the hostilities, but in the early 1920s, he produced important bodies of work at Versailles and Saint-Cloud.

Marchand abat-jours, rue Lepic was purchased from the Stephen Daiter Gallery in 1993. The previous owner had bought it in the 1970s from Julien Levy, the proprietor of a New York gallery. It is one of eight photographs by Atget in the museum's collection.

Jean-Eugène-Auguste Atget, French, 1857–1927
Marchand abat-jour, rue Lepic, Paris, 1899–1900, albumen print
8 7/8 x 6 3/4 inches (image and sheet)
"Marchand abat-jour" and "8196" (Atget's negative number), in pencil,
 verso; "E. ATGET/rue Campagne-Première, 17 bis" wet stamp, verso
Alfred and Ingrid Lenz Harrison Fund, 93.2.1

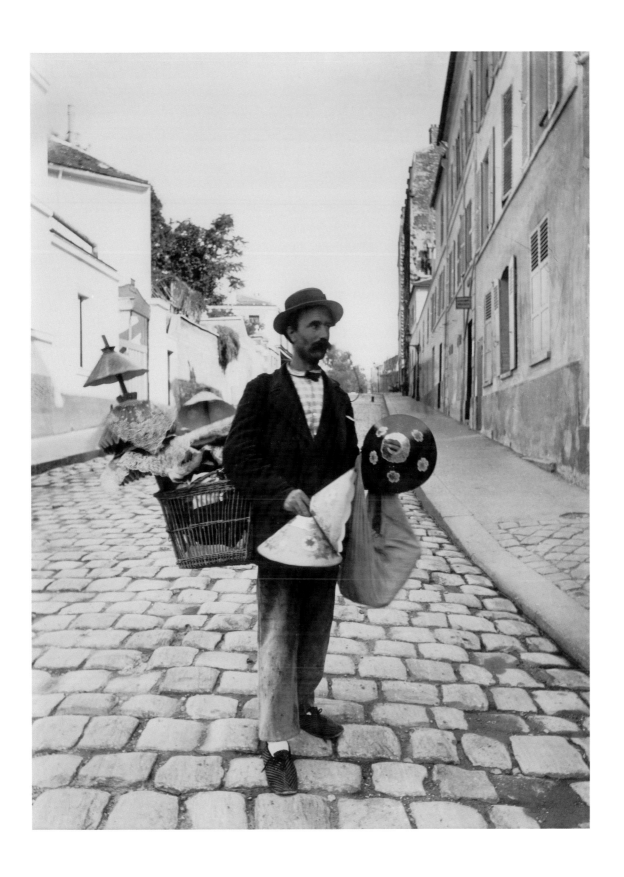

Camera Work

CAMERA WORK is the most lavish photographic magazine ever published in the United States and the one most responsible for validating photography as a fine art in this country. Edited by Alfred Stieglitz, the patriarch of American creative photography, it featured nearly 500 high-quality illustrations and insightful articles by artists, critics, and photographers.

Stieglitz launched the quarterly after serving as editor of *Camera Notes* (1897–1903), the respected journal of the Camera Club of New York. Although *Camera Work* was described as the "mouthpiece" of the Photo-Secession, an elite group of artistic photographers, Stieglitz himself wielded complete control over the magazine. Most of the plates were printed by photogravure, an intaglio method (think "photo-etching") that yielded images of considerable richness and subtlety. The photographers often supplied their original negatives to help make the printing plates and also were involved in proofing the gravures, many of which were printed on delicate Japanese tissue and then hand-tipped onto pages separate from the magazine's text. Not surprisingly, the periodical was produced in limited numbers (1,000 per issue at most) and priced higher than any other photographic magazine. A total run of *Camera Work* comprises fifty issues in forty-eight numbers, due to a few double issues and special numbers.

Camera Work exemplified quality design and production values at the beginning of the twentieth century. Its cover featured a clean, understated design by Edward Steichen, a young photographer who previously had worked as a commercial artist and printer. The elegant text, set with justified lines and wide margins, was printed by letterpress on handmade paper with deckle edges, using an old-style typeface, a heavy impression of ink, and ornamental initials. Significantly, the advertisements were relegated to the rear of each issue, far from the refined illustrations.

Stieglitz included the work of about fifty American and European pictorialists in *Camera Work*. Among the most well represented were: Alvin Langdon Coburn, known for his portraits and city scenes; Gertrude Käsebier, America's leading female photographer; Steichen, who, to Stieglitz's delight, both painted and photographed; Clarence H. White, whose figure studies were ethereal and evocative; and Stieglitz himself. Today, individual photogravures from *Camera Work* are so sought after that few issues and complete runs remain intact.

In 1964, Ted Hartwell secured a full set of *Camera Work* as his first acquisition for the museum. It was purchased from E. Weyhe, one of New York's most venerable used-book shops, for $500. Amazingly, just four years later, another, near complete, set of the periodical was given to the MIA by Julia Marshall, a Duluth resident who had studied with White. Consequently, the museum has the rare privilege of keeping one set intact and being able to remove gravures from the other for display purposes.

Camera Work, 1903–17, fifty issues
Periodical published by Alfred Stieglitz, New York
12 3/8 x 9 inches (cover)
William Hood Dunwoody Fund, 64.34.1-50

Lewis W. Hine

THIS YOUNG MESSENGER BOY'S CAP bears a
metal plate with the name of his employer, the American
District Telegraph Company (A.D.T.), an affiliate of Western
Union. By coincidence, the very year this image was
made (1910), Western Union bought controlling interest in
A.D.T., making it the nation's leader in messenger and
telegraph services. Such domination no doubt worsened
working conditions for countless young employees
exploited by big business early in the twentieth century.

Horrified by these circumstances, Lewis Wickes Hine
made it his mission to document the plight of workers
and to crusade for change. In this image, the weary
subject gazes directly into the lens, typifying what Hine
called the "human junk" that was created by a callous
industry. The boy has already been robbed of his childhood;
his official cap and herringbone-pattern coat suggest an
adult profession, only reinforcing the fact that he was
growing up too fast. This image, unlike many of Hine's
others, isolates the subject rather than placing him in
his work environment. As a consequence, the child's
sad situation and loneliness are all the more apparent.
According to information on the back of a print of this
image in the collection of the Milwaukee Art Museum, the
subject was a fourteen-year-old named Richard Pierce.
He worked from 7:00 a.m. to 6:00 p.m., smoked cigarettes,
and visited houses of prostitution.

Hine was a sociologist who turned to photography
in order to advance the social-reform movement
of the early twentieth century. He taught at New York's
Ethical Culture School, and photographed many
of the European immigrants arriving at Ellis Island.
In 1908, he began working for the National Child Labor
Committee, an early nonprofit organization dedicated
to exposing the harm done to young American workers.
During the next ten years, Hine traveled throughout
the eastern half of the United States, photographing
children laboring in mills, mines, factories, fields,
and sweatshops and on urban streets. His images, drawn
from nearly 5,000 negatives, were widely reproduced
and exhibited, helping to persuade the government to
enact child-labor laws. During World War I, Hine worked
for the Red Cross in the European theater. He began
his last important body of work—documenting the
construction of New York City's Empire State Building—
in 1930; his book *Men at Work* contains many images
from this project, along with other photographs of
adult laborers.

This photograph is one of fifty by Hine purchased
in 1974 from Harry Lunn's Graphics International,
Washington, D.C., for fifty dollars each. The Minneapolis
Institute of Arts now owns nearly ninety photographs
by Hine.

Lewis W. Hine, American, 1874–1940

Messenger Boy, Wilmington, Delaware, 1910, vintage gelatin silver print

4 11/16 x 3 11/16 inches (image), 6 9/16 x 4 15/16 inches (sheet)

Wet stamps, verso: "N," "Set No.," and "IN ORDERING USE THIS NUMBER/N.
15 21/HINE PHOTO COMPANY/27 GRANT AVE. LINCOLN PARK/YONKERS, N. Y."
in octagon border, plus numbers in pencil

Ethel Morrison Van Derlip Fund, 74.39.22

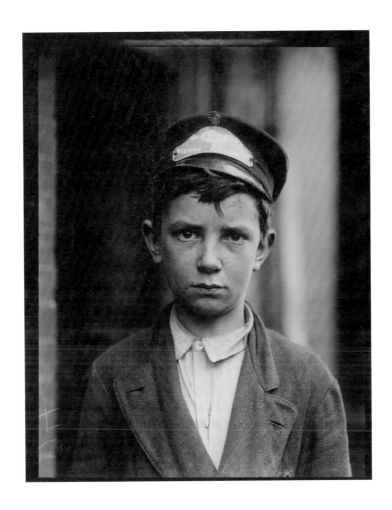

Paul Outerbridge, Jr.

PAUL OUTERBRIDGE, JR., made this minimalist image early in his career and the same year (1922) as his most well-known image, *Ide Collar*. In *Knife and Cheese*, he precisely arranged the simple objects to make an elegant cubist composition. Straight lines and geometric shapes animate the framed space, which contains a limited number of tonalities. The photographer cleverly accentuated all four corners by creating triangles of varying sizes.

Outerbridge, an advertising photographer for most of his career, may have made this image on assignment. Commercial photographs from between the world wars often excluded labels and brand names, instead alluding to the lifestyle and culture associated with the product. *Knife and Cheese*, for instance, suggests a sophisticated snack, and could have been used to advertise any of the objects—knife, cheese, crackers, or cutting board—shown. Outerbridge rendered this print in platinum, adding a delicacy and warmth suitable to the subject. Such subtleties were lost when his pictures were reproduced in magazine advertisements, but their graphic power remained.

Outerbridge's primary personal subjects were still lifes and female nudes. During the 1920s, he printed almost exclusively on platinum paper, but in the 1930s, he adopted the new color process of carbro, which rendered images in heavily saturated hues. Many of his color nudes suggested sexual fetishism and were considered risqué for their time.

Knife and Cheese, the only photograph by Outerbridge that the MIA owns, was purchased from the New York dealer Timothy Baum, who acquired it from the photographer's estate.

Paul Outerbridge, Jr., American, 1896–1958
Knife and Cheese, 1922, platinum print
4 1/2 x 3 9/16 inches (image and sheet), 14 x 11 inches (mount)
Signature and date, in pencil, below print
Alfred and Ingrid Lenz Harrison Fund, 98.55

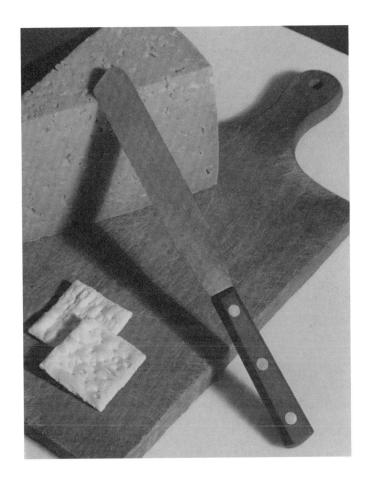

Paul Strand

REBECCA ("BECK") SALISBURY married
Paul Strand in January 1922, the year he made this
portrait of her. The tightly framed image shows Rebecca's
strong profile nearly life size and slightly blurred.
Her closed eyes suggest sleep and the softness of the
image a dreamlike state.

Rebecca spent most of the summer of 1922 at the
upstate New York summerhouse of Alfred Stieglitz, while
Strand pursued commercial work elsewhere. She quickly
became close to her host and his wife, Georgia O'Keeffe,
and Stieglitz frequently photographed her; in fact,
he became rather infatuated with the vivacious young
Rebecca, who bore a slight resemblance to O'Keeffe.
Stieglitz photographed Rebecca's nude body and
hands, just as he had O'Keeffe's. Curiously, when Strand
commenced his own extended portrait of his wife,
Stieglitz was somewhat irritated by the similarity of
treatment. Rebecca and Paul Strand divorced in 1932, the
same year Strand parted ways with Stieglitz.

Strand studied photography with Lewis W. Hine at
the Ethical Culture School in New York in 1908. Soon after

being exposed to modern art at Stieglitz's gallery "291,"
he began to make some of the first almost abstract
photographs of household objects. These images
were featured in the last two issues of Stieglitz's deluxe
magazine *Camera Work* in 1916–17, signaling the end of
the first movement of artistic photography—pictorialism.
During the 1920s and 1930s, Strand worked as a freelance
cinematographer. In 1940, he issued a portfolio titled
Photographs of Mexico, containing twenty photogravure
images of the country's people and religious icons.
Strand moved to Europe in 1950 to escape America's
conservative political climate, and lived most of his
remaining years in a small French village. He continued
to produce books, which he filled with images of people
native to France, Spain, Scotland, Egypt, and Ghana.

Rebecca Strand, New York City was purchased from the
Paul Strand Trust in 1982, six years after the photographer's
death. The museum owns about twenty-five prints
by Strand plus a copy of *The Mexican Portfolio*, a 1967
reissue of the 1940 portfolio, and all seventeen of his
photogravures from *Camera Work*.

Paul Strand, American, 1890–1976
Rebecca Strand, New York City, 1922, platinum print
7 5/8 x 9 5/8 inches (image and sheet), 8 1/8 x 10 1/8 inches (mount)
"Paul Strand HS," in pencil in Hazel Strand's hand, verso
William Hood Dunwoody Fund, 82.88.1

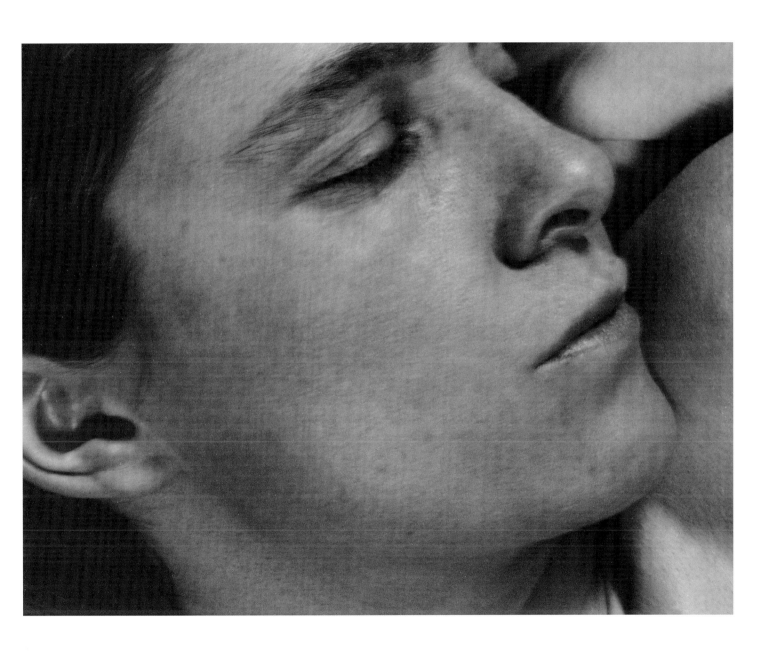

Jaromír Funke

JAROMÍR FUNKE helped lead Czech photographers into the modernist era, a period that saw the development of constructivism in Soviet Russia and the Bauhaus in Germany. Because Czechoslovakia, which came into existence following World War I, sat at the crossroads between eastern and western Europe, it absorbed artistic, social, and political influences from both sides of the continent. Early in the century, its artists were among those dismantling the barriers between art and life, creativity and commerce.

Funke's earliest photographs were romantic and softly focused, but soon he was making bolder, more hard-edged images. In the 1920s, he produced a series of still lifes—small groups of machine-made materials such as paper, board, glass, mirrors, bottles, and balls—that explored the abstract nature of the photographic medium. The minimalist subject matter of *Composition* consists of two sheets of glass precariously balanced next to a ball and a curving sheet of paper. Because most of these shapes are geometric and inorganic, the effect is an almost abstract pattern of light and shadow. The image reduces subject matter to a minimum, allowing form to follow function. Much of what is visible in the picture—reflections, shadows, and light itself—lacks a physical presence. Modernist photographers were intrigued with such phenomena because they evoked a feeling of ambiguity and disorientation.

Funke associated closely with other modernists such as Josef Sudek and Adolf Schneeberger. He influenced Czech avant-garde photography in many ways—by writing critical articles and reviews, teaching photography at trade schools, and breaking new ground with his distinctive images.

Composition was purchased in 1993 from the Howard Greenberg Gallery, New York, which acquired it from a collector in Prague. The MIA owns one other print by Funke.

Jaromír Funke, Czech, 1896–1945
Composition, 1923, vintage gelatin silver print
11 5/16 x 15 3/8 inches (image and sheet)
No inscriptions
Alfred and Ingrid Lenz Harrison Fund, 93.45

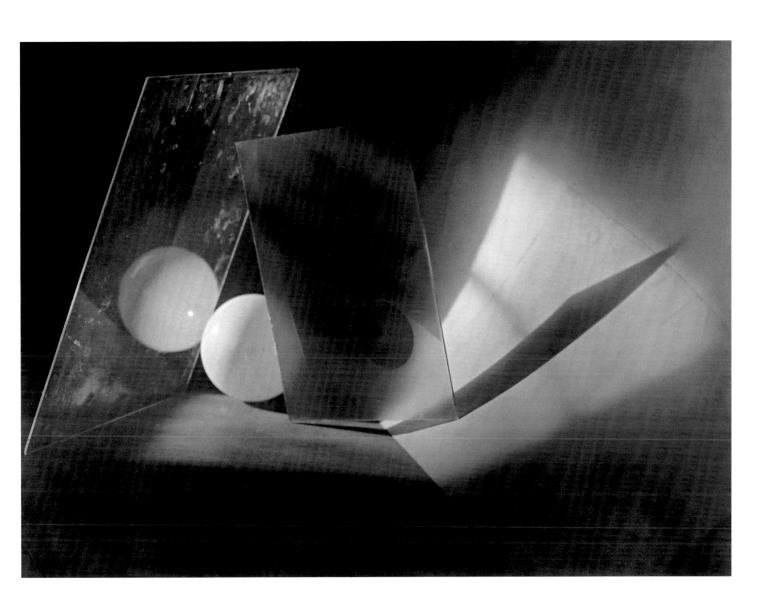

Tina Modotti

IN 1929, Tina Modotti produced a series of sensitive photographs of Mexican puppets and their makers, including this one. Her primary subject was the work and hands of her friend Louis Bunin, an assistant to the great Mexican painter Diego Rivera. Bunin and Modotti shared an enthusiasm for the indigenous marionette theater, which was popular in a country known for its handicrafts. Modotti photographed Bunin's puppets either isolated against ominous backdrops or tethered to their operators.

In *Hands of the Puppeteer*, Bunin seems tangled up in the strings of his creation; his hands appear passive, rather than active, and incapacitated, rather than controlling. Modotti used raking light to shroud her subject in partial shadow and tight cropping to create a claustrophobic effect. Her symbolic keynote was manipulation—personal, cultural, and political.

Born in Italy, Modotti immigrated as a young woman to the United States. In 1923, she moved with Edward Weston from Los Angeles to Mexico City, where Weston established a portrait studio and Modotti learned photography. On her own, she photographed for less than a decade, leaving a legacy of fewer than 300 finished prints. In 1930, the Mexican government deported her for political activities, and she spent her remaining years supporting socialist causes in Europe and Russia. Modotti's colorful life—much of which she spent decrying injustice—is recounted in three biographies.

This print was in the personal collection of the subject, the puppeteer Louis Bunin, who probably received it as a gift from the photographer. In 1985, the MIA purchased it from the Edwynn Houk Gallery, Chicago, and it remains the only photograph by Modotti in the permanent collection.

Tina Modotti, Mexican (born Italy), 1896–1942
Hands of the Puppeteer, Mexico City, 1929
Vintage gelatin silver print
9 15/16 x 7 15/16 inches (image and sheet)
No inscriptions
Mr. and Mrs. Patrick Butler Fund, 85.87

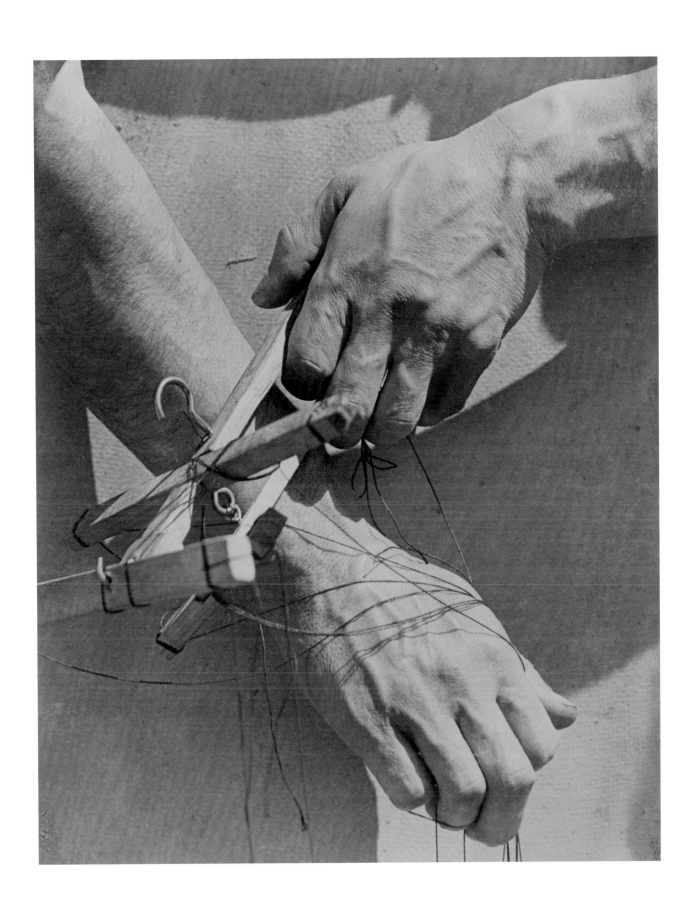

László Moholy-Nagy

LÁSZLÓ MOHOLY-NAGY made this undated photogram the same way he made all his others in the 1920s and 1930s—by laying objects on a sheet of undeveloped photographic paper, which he then exposed to light. The identity of the items he photographed—usually such commonplace objects as matches and napkin rings—was of little interest to him. For this image, it appears that he used strips of cut paper. The work is unusual among Moholy-Nagy's photograms because he apparently created the materials and because the shapes are so fanciful. The overlapping paper strips create fluid forms that seem to swirl back and forth in space. Moholy-Nagy nicely contrasted these ribbon shapes with the straighter, starlike elements on the bottom. Adding to the liquid sensation of this image are the bubbles that line the left edge, probably the result of his casually inserting the paper into the developing solution.

Moholy-Nagy (pronounced Mo-hoy-Neug, according to one of his daughters) was an innovative painter, sculptor, and filmmaker. He made his living as a teacher, commercial artist, and writer, and never considered himself a photographer per se, although he used the still camera to make photo-collages, photograms, and conventional camera-generated images. In the 1920s, he

helped define the "New Vision" in Germany, a movement that used a variety of media to meld technology and creativity. Moholy, as he was known to friends, once stated that "the illiterate of the future will be ignorant of camera and pen alike."

Born in Hungary, Moholy-Nagy moved to Berlin in 1920 to pursue art, and shortly thereafter began making photograms. Between 1923 and 1928, he taught at the Bauhaus design school, first in Weimar and then in Dessau. Prompted by the rise of Nazism, he left Germany in 1935, and two years later became director of the New Bauhaus in Chicago. In 1939, the school was reconfigured as the Institute of Design, where he taught until his death.

This photogram was given to Ralph Rapson, who headed the Institute of Design's architecture program from 1942 to 1945. During this period, Rapson helped Moholy-Nagy organize materials for his book *Vision in Motion*, published posthumously in 1947; this image was not selected for inclusion, so Moholy offered it to his young colleague. Rapson eventually moved to Minneapolis, where he designed furniture and buildings such as the original Guthrie Theater (1963). In 1999, the MIA acquired this print as a combination gift/purchase, making it the second in its collection by Moholy-Nagy.

László Moholy-Nagy, American (born Hungary), 1895–1946
Untitled, undated, vintage gelatin silver print (photogram)
10 7/8 x 8 7/8 inches (image and sheet)
No inscriptions
Alfred and Ingrid Lenz Harrison Fund and partial gift
 of Ralph Rapson, 99.9

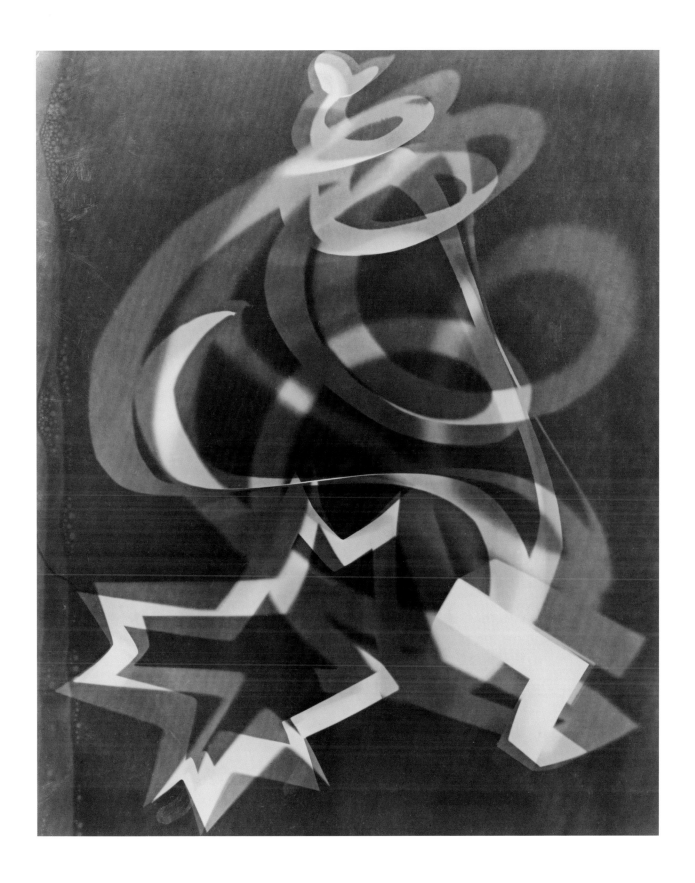

Man Ray

THE BEAUTIFUL LEE MILLER (1907–77) was a model, war correspondent, and photographer. In 1929, she moved from New York to Paris, where she became Man Ray's assistant and lover. Later, she ran her own portrait studios in Paris and New York, and lived in Egypt for a time. She relocated to London just before World War II broke out, and subsequently wrote about and photographed the conflict for *Vogue*. She lived the rest of her life on an English country estate with her husband, Roland Penrose, a biographer of numerous artists.

Man Ray made this tender nude study of Miller at the beginning of their affair, when she was twenty-three years old. She is seated on a bed, surrounded by fabric and bathed in a gentle light from above. The softness of both the focus and the illumination suggests innocence, a sentiment echoed by the modest positioning of Miller's head and leg. Another photograph shows Man Ray, dressed in a bathrobe, standing next to a print of this image tacked to his bedroom wall.

Born Emmanuel Radnitsky in Philadelphia, Man Ray became an artist in New York before moving, in 1921, to Paris, where he supported himself making portraits and fashion photographs. He photographed many cultural luminaries and became closely associated with the Dadaists and Surrealists. Experimenting in the darkroom, he also made photograms—so-called rayograms—and solarized images, in which tones were reversed and outlines emphasized. He also created prints, drawings, and sculptures, which frequently challenged traditional aesthetic sensibilities. In 1940, Man Ray left Europe because of the German occupation and settled in Los Angeles, where he continued to produce and exhibit a large body of work. He returned to Paris in 1951, and remained there the rest of his life.

This print previously belonged to Lord Palumbo, an English property developer and art collector, who passed it to the Edwynn Houk Gallery, New York. In 2006, the MIA purchased it from the Weinstein Gallery, Minneapolis, adding it to four other photographs by Man Ray, including another of Lee Miller.

Man Ray, American, 1890–1976
Lee Miller, 1930, vintage gelatin silver print
11 3/8 x 9 inches (image and sheet)
"MR" and date, in pencil, verso; two wet stamps,
 verso: "EPREUVE ORIGNALE/Atelier Man Ray/PARIS"
 and "MAN RAY/PARIS"
Alfred and Ingrid Lenz Harrison Fund, 2006.85.1

Edward Weston

PRODUCED BY A MASTER OF THE MEDIUM, Edward Weston, this is one of the most well-known images in the history of creative photography. It shows a tightly framed bell pepper, glowing with light and surrounded by deep shadows. The sinuous lines of the vegetable are simultaneously beautiful and contorted. Its organic form also suggests the female nude and sexual activity, although Weston always denied these interpretations. A small, dark spot on the lower right side of the object hints at its perishable nature. Weston photographed this pepper and many others in a tin funnel, which neatly contained the subject and provided a stark contrast in material and surface.

Weston spent four days in the summer of 1930 exposing at least thirty different negatives of peppers. He credited his student and lover, Sonya Noskowiak, with supplying him with the vegetables, and wrote about this particular one in his journal: "Something kept me from taking it to the kitchen, the end of all good peppers." Nonetheless, once Weston had photographed the pepper, he ate it, literally devouring the subject of his art. Weston himself made about twenty-five prints of *Pepper No. 30*, never finishing the edition limitation of fifty. His prints usually bear his full signature on the mount, whereas later prints by his sons have only his initials or a stamp on the back.

In 1906, the twenty-year-old Weston moved from Illinois to California, where he spent virtually the rest of his life. He worked in a few Los Angeles portrait studios, and in 1911, opened his own, in Tropico (now Glendale).

Initially, Weston made soft-focused, pictorial images, but in 1922, he began to work in a more straightforward, modernist manner. He lived and photographed in Mexico with fellow photographer Tina Modotti in the mid-1920s, and in 1932, was a founding member of Group f.64, a small league of art photographers committed to sharp focus and a full range of tones in their work. In 1937, Weston received the first Guggenheim grant given a photographer; the award enabled him to photograph the California landscape for a book on the subject. He began living near Carmel in 1938 and frequently photographed nearby Point Lobos. Only a few years after the Museum of Modern Art, New York, presented a one-person exhibition of his work, in 1946, Weston was forced to stop photographing due to the debilitating effects of Parkinson's disease. From the 1920s to 1940s, Weston kept extensive journals in which he reflected on his life and creative challenges; extracts from what he called his "daybooks" were published after his death. He is best known for his clean, crisp photographs of nudes, vegetables, landscapes, and still lifes.

This photograph came to the museum in 1984 from the estate of Dorothy Millett Lindeke, a relative of James J. Hill, the Minnesota financier and railroad magnate. In 1932, Lindeke and other family members visited Carmel, where Weston made portraits of them; they probably purchased this print of *Pepper No. 30* at that time. Because this print has the low edition number of three, obviously it was one of the earliest made. The museum owns forty-four photographs by Weston, including a print of *Pepper No. 30* by Edward's son Cole and the *Fiftieth Anniversary Portfolio* (1952).

Edward Weston, American, 1886–1958
Pepper No. 30, 1930, vintage gelatin silver print
9 7/16 x 7 1/2 inches (image and sheet), 16 7/16 x 12 9/16 inches (mount)
Full signature, date, and edition number (3/50) in pencil,
 on mount below print
Bequest of Dorothy Millett Lindeke, 84.56.1

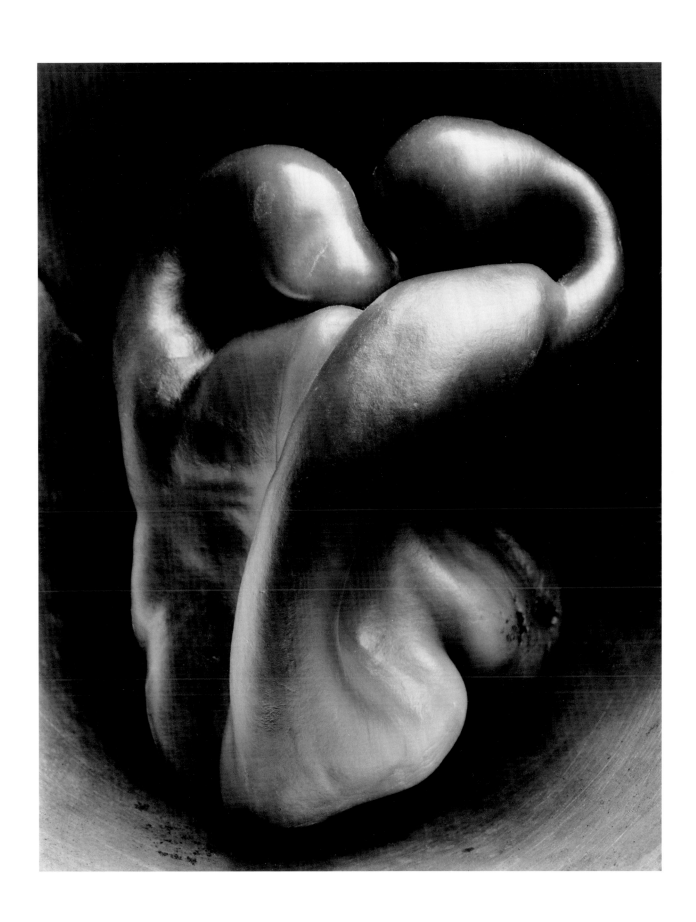

Hans Bellmer

THE DOLL (*LA POUPÉE*) was Hans Bellmer's primary photographic subject. He published three limited-edition books on the theme, all with original photographs, such as this well-known example. Here, Bellmer presents a female manikin, partially dismembered and rendered in negative tones. Its lack of arms and split skull suggest it has been treated brutally and is now defenseless. The body parts of most interest to Bellmar, however, are uncompromised: the breasts, stomach, and pubis appear front and center, delineated by white highlights at the nipples, belly button, and crotch.

Death, decay, and decadence pervade the image. The lace backdrop evokes a funeral parlor, and the prominent rose hints at Charles Baudelaire's *Les Fleurs du Mal*. Most tellingly, the tones of the entire picture have been reversed, making it a negative image: as black is to white, death is to life.

Bellmer developed as an artist in the 1920s while living in his native Germany, where he supported himself as a designer. He became interested in the psychoanalytic theories of Sigmund Freud and acquainted with the macabre artistry of Otto Dix and George Grosz. In 1933, he constructed his first doll and posed it suggestively for his camera. This and subsequent dolls became objects of desire and obsession, and the photographic images he made of them were considered elegantly erotic by some and perversely pornographic by others.

When Bellmer moved to Paris in 1938, his work became more surrealistic, imbued with a sense of mystery and the subconscious. At the beginning of World War II, he was imprisoned briefly because of his German heritage; he subsequently secured French citizenship. A prolific painter, printmaker, and sculptor, Bellmer was particularly skilled as a draftsman, making drawings of sinuous lines and voluptuous shapes. All his work reflected his deep interest in human sexuality and its graphic depiction.

La Poupée was purchased in 2001 from the San Francisco dealer Charles Hartman. In addition to this photograph, the museum owns one etching and one book illustrated by Bellmer.

Hans Bellmer, French (born Germany), 1902–75
La Poupée, 1934, vintage gelatin silver print
From the book *La Poupée: Souvenirs à la Poupée*, 1936
4 5/8 x 3 1/16 inches (image and sheet), 6 5/16 x 4 13/16 inches (mount)
No inscriptions
Alfred and Ingrid Lenz Harrison Fund, 2001.238.2

Walker Evans

THE BELLE GROVE RESIDENCE was designed in 1857 by the architect James Gallier, Jr., for the wealthy Virginia planter John Andrews. It was one of Lousiana's grandest Greek Revival mansions, containing seventy-five rooms and much detailed woodwork. Unfortunately, the structure deteriorated significantly during the 1920s, and ultimately was razed after World War II.

In 1935, Walker Evans took a two-month trip to the South to photograph disappearing plantation houses for a book project that never materialized. He went to Belle Grove with an employee of the Works Progress Administration and the painter Jane Ninas, whom he later married, and initially photographed its exterior. His companions, however, broke into the house, giving Evans the opportunity to work inside as well. Reportedly, he made only one negative; the result is this photograph of the drawing room.

Evans set up his large camera to capture one wall of the room. The imposing Corinthian columns march across the frame like sentries, illuminated from the open window to the left. Although the window shutters in the distance are closed, the hot summer sun shines through, creating a T-shaped highlight. Despite water damage to the ceiling and some refuse on the floor, the room reflects a sense of its former grandeur. Evans allowed his lens to cut off the upper corners of the image, a technique that helped contain and humanize the large volume of the room. Prints of *Room in Belle Grove Plantation House* are often slightly cropped on the top and left, thus eliminating all or part of the window. This one shows the entire negative, with black borders, and was made on warm-toned, double-weight paper.

Evans enjoyed a long life in photography, making his own pictures, editing those of others, and teaching. After photographing the streets of New York with a small camera in the late 1920s, he acquired a large-format camera and concentrated on capturing Victorian houses in New York State and New England. During the Depression, he made his most important body of work, documenting the vernacular architecture and poor living conditions of the South. In 1938, the Museum of Modern Art, New York, devoted its first one-person photographic exhibition to Evans's achievement and published *American Photographs,* now considered one of the most influential photography books of the twentieth century. In 1945, he joined the staff of *Fortune,* and for the next twenty years, wrote, edited, and photographed for the magazine, helping to define its distinctive documentary style. Evans spent much of his final decade teaching photography at Yale University. A few years before he died, he discovered the instant gratification of taking photographs with the Polaroid SX-70 camera and generously gave away many of them.

This print was given to the museum in 1975 by D. Thomas Bergen, who was involved in the purchase of Evans's photographs by George Rinhart and Harry Lunn, shortly before the photographer's death. The MIA's permanent collection contains 113 prints by Evans.

Walker Evans, American, 1903–75
Room in Belle Grove Plantation House, Louisiana, 1935
Vintage gelatin silver print
7 9/16 x 9 9/16 inches (image), 7 15/16 x 9 15/16 inches (sheet)
Lunn Gallery wet stamp, with "II" and "76" penciled
 into the two rectangles, verso
Gift of D. Thomas Bergen, 75.41.10

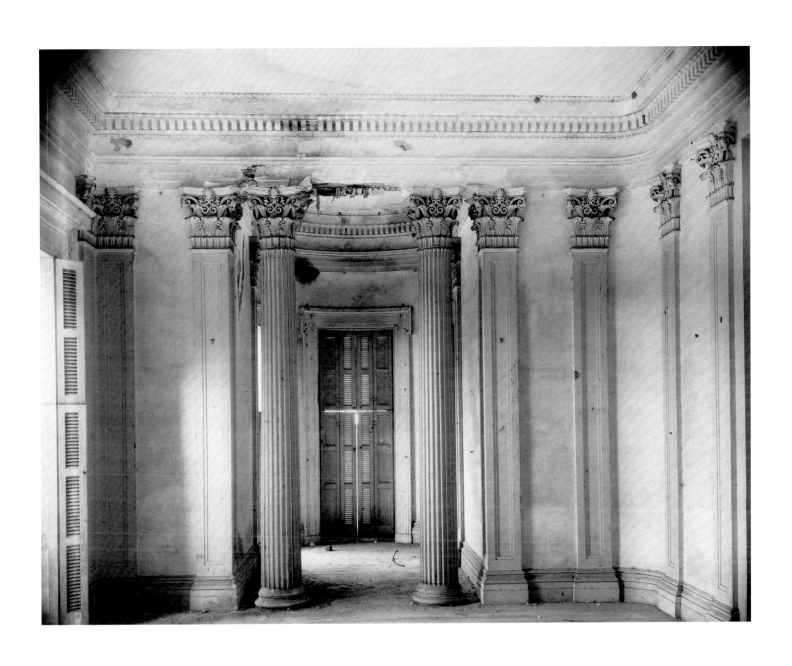

Walker Evans

THIS POIGNANT PORTRAIT of Allie Mae Burroughs was made in 1936, when Walker Evans and James Agee were working on a proposed piece on southern sharecroppers for *Fortune*. In order to better understand a typical family's impoverishment, the photographer and the writer stayed for a time with the Burroughses in their spartan four-room house. Evans's intimate images teamed with Agee's forthright prose to create not a magazine article but a masterful book, *Let Us Now Praise Famous Men*, published in 1941. At the beginning of the volume, even before the title page, are thirty-one of Evans's images; this one is third.

Evans actually made four negatives of Allie Mae, each showing her with a slightly different facial expression. Three reveal a hint of a smile, but in this one, her mouth and eyes betray a sense of defeat. Her pinched features and dead-eye gaze make her seem old beyond her years. Her thin, tight lips appear sealed, suggesting she has been silenced or is too weary to speak. Allie Mae's haggard face, her soiled dress, and the clapboard siding behind her convey a bleak message about a troubled time and place.

This photograph was made during a two-year period (1935–37) of great artistic intensity for Evans. He was working for the U.S. government's Farm Security Administration (F.S.A.) to record the plight of the rural poor during the Depression—traveling from Pennsylvania and West Virginia to Georgia and Mississippi and photographing small-town and rural folk, including coal miners, tenant farmers, prisoners, and shopkeepers. He was equally interested in the vernacular architecture of the places he visited, turning his camera on houses, churches, storefronts, and government buildings, always with a keen eye to signage. The images Evans made during this period were consistently authoritative, precise, and emotionally detached.

Most of the MIA's photographs by Walker Evans were made in the 1930s, largely for the F.S.A. This print was acquired with twenty-eight others in 1975 from Graphics International, Harry Lunn's Washington, D.C., gallery.

Walker Evans, American, 1903–75
Allie Mae Burroughs, Wife of a Cotton Sharecropper,
 Hale County, Alabama, 1936, vintage gelatin silver print
9 1/2 x 7 9/16 inches (image), 9 15/16 x 8 inches (sheet)
Lunn Gallery wet stamp, with "1" and "36" penciled into
 the two rectangles, verso
William Hood Dunwoody Fund, 75.26.14

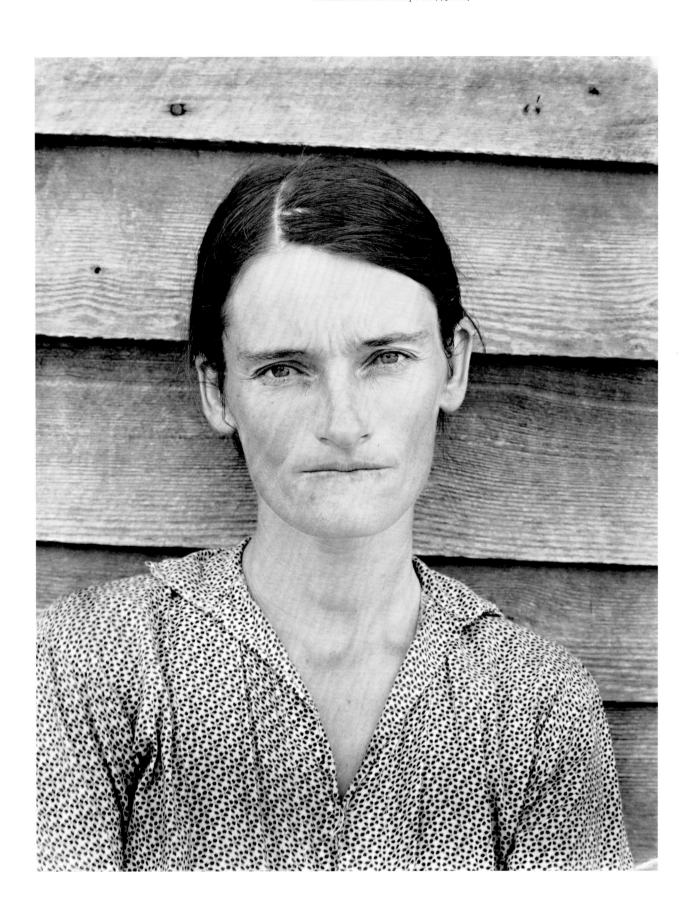

Dorothea Lange

DURING THE DEPRESSION, the U. S. government hired Dorothea Lange and many other photographers to document the plight of poor Americans and the programs enacted to assist them. Lange began working in 1935, and a year later, made this image on her first major trip for the Farm Security Administration. Driving alone one dreary March day, Lange came across a pea-pickers' camp about 150 miles up the coast from Los Angeles. She was struck by one family in particular—this discouraged mother and her hungry children. She later described the scene: "In a squatter camp at the edge of the pea fields. The crop froze this year and the family is destitute. This morning they had sold the tires from their car to pay for food. She is 32 years old."

Lange spent only about ten minutes with the subject, making five exposures. The family's meager possessions appear in some, but this one captures only the human side of the tragedy. Lange anchors the tightly framed image with the migrant mother, flanked by two shabbily dressed children and holding a third. While the older two shyly turn away from the camera, the pale, dirty face of the youngest one is visible on the woman's lap. The out-of-focus element along the right side of the frame is one of the vertical supports for the family's makeshift, open-sided tent. This moving portrait of shared despair

was widely reproduced in newspapers and magazines during the late 1930s, and today remains one of the iconic photographs of the Depression.

During the mid 1910s, Lange studied photography with the pictorialist Clarence H. White, and worked in various New York portrait studios. In 1919, she opened her own in San Francisco, where her subjects were some of the city's most prominent citizens. Beginning in 1935, she worked for the federal government for nine years, documenting the Depression for the Farm Security Administration, the Department of Agricultural Economics, and the Office of War Information. In 1939, Lange and her husband, Paul S. Taylor, published their picture-text collaboration, *An American Exodus*. She basically stopped making pictures in the late 1940s, but then helped found *Aperture* magazine in 1952. During the 1950s, Lange produced picture essays for *Life* and traveled extensively—to South America, Europe, Asia, and the Middle East. A major retrospective of her work opened at the Museum of Modern Art, New York, in January 1966, a few months after her death.

This print of *Migrant Mother* was purchased in 1991 from the Howard Greenberg Gallery, New York, which had acquired it from Martha MacMillan Roberts. The museum has seven photographs by Lange, including *White Angel Breadline, San Francisco*.

Dorothea Lange, American, 1895–1965
Migrant Mother, Nipomo, California, 1936
Gelatin silver print (printed 1940 or before)
13 5/16 x 10 5/16 inches (image and sheet), 13 7/8 x 11 inches (mount)
No inscriptions
Alfred and Ingrid Lenz Harrison Fund, 92.136

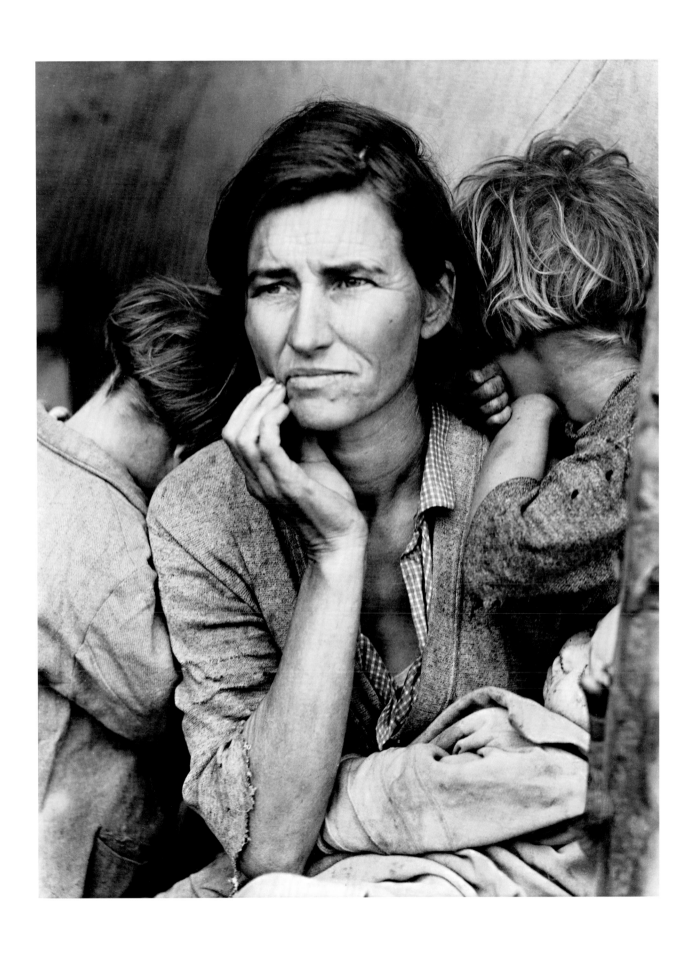

Arthur Rothstein

LIKE DOROTHEA LANGE'S *MIGRANT MOTHER*, this is one of the most memorable images of the Great Depression. Arthur Rothstein made it when he was only twenty years old, having recently begun working for the federal government's Farm Security Administration. In the spring of 1936, he traveled to the panhandle of Oklahoma to document the devastation in the so-called dust bowl, where windstorms were sweeping away tons of topsoil, burying farmhouses, and killing livestock.

Years later, Rothstein recalled:

The desolation of the bleak landscape impressed me, but the thing that really moved me was not the abandoned farms themselves. It was the strong people who were determined to survive, who would not give up their land, their homes. I still vividly recall the most dramatic event of the trip. It was late in the afternoon. I was about to leave one of the most devastating scenes of the dust bowl tragedy. As I was saying goodbye to one of the few remaining farmers, we found ourselves faced with the onslaught of another terrible dust storm. I ran for my car. The farmer and his two boys ran for the safety of their home. I turned back and squinted through the dense swirling cloud of dust and sand. It was at that decisive moment that I clicked the shutter. I had captured my most famous and historically important photograph. Later I realized that this family's courage and perseverance characterized what I've always

felt was our great American spirit: to overcome adversity and to keep fighting for a better life.

The rippling of the figures' clothes and the gray blurriness evoke a raging tempest. So do the postures of the man and boys; they lean into the fierce wind as they struggle toward their humble shelter. The horizontal format of this print increases the sensation of movement from right to left. Sadly, the family's wooden hut seems to offer little potential protection from the storm, as it is already partially buried in soil and sand.

Rothstein was a photojournalist for nearly a half century, beginning in 1935. Roy Striker, his former teacher, hired him right out of college to photograph for the U.S. Resettlement Administration. Rothstein later claimed that his government work took him to every county in the country. During World War II, he photographed for the U. S. Army Signal Corps in the Asian theater, and in 1946, he began a career that lasted nearly twenty-five years—as the director of photography for *Look* magazine. His last position was as associate editor of *Parade*, a widely circulated national Sunday-newspaper supplement. Rothstein also wrote numerous books and articles on documentary photography.

The MIA purchased *Dust Storm* in 1992 from Chicago dealer Stephen Daiter, who acquired it from an editor of *U.S. Camera* magazine. It is one of thirty-two photographs by Rothstein in the collection.

Arthur Rothstein, American, 1915–85
Dust Storm, Cimarron County, Oklahoma, 1936, vintage gelatin silver print
10 7/8 x 13 5/8 inches (image and sheet), 11 1/16 x 13 15/16 inches (mount)
Traces of what was probably Rothstein's signature
 (due to trimming of the mount), below print
Gift of funds from Alfred and Ingrid Lenz Harrison, 92.76

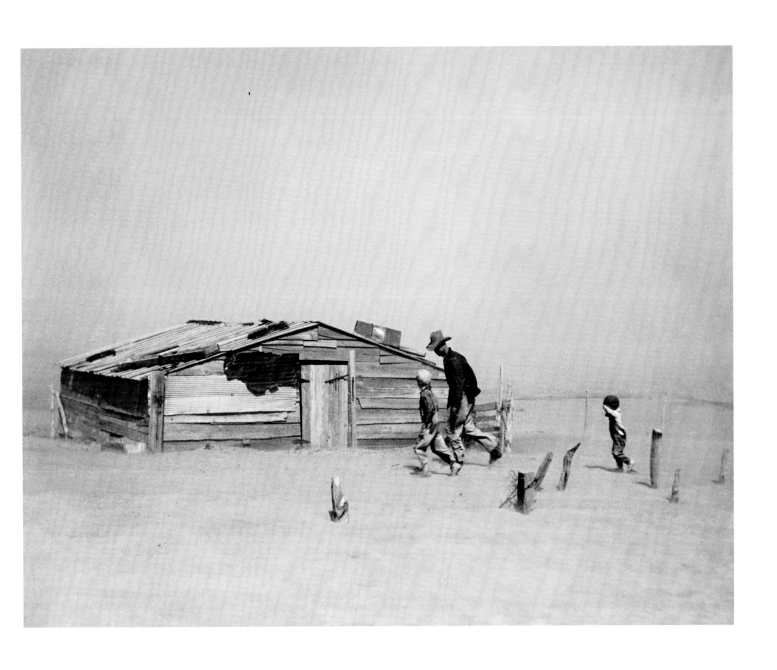

Alfred Stieglitz

NEW YORK'S SHELTON HOTEL opened in 1924 as a residential club-hotel for men, equipped with recreational facilities, lounges, reading rooms, and a cafeteria and restaurant. Located on Lexington Avenue at Forty-ninth Street, it was one of the first buildings to incorporate setbacks, and at thirty-four stories, it towered over most of its neighbors. Newlyweds Alfred Stieglitz and Georgia O'Keeffe moved into the Shelton in 1925, by which time women were allowed. The bedroom in their two-room suite near the top of the building was sunny, and the spartan living room doubled as O'Keeffe's painting studio. The couple lived there for a decade, until 1935, the year Stieglitz made this photograph.

During his last spring in the building, Stieglitz exposed at least eleven negatives of this same western view; they showed the upper façades of the Newsweek Building and, on the left, the sleek RCA Building (before the addition of other elements of Rockefeller Center). Stieglitz seemed interested in the outsized human ambitions represented by these towering skyscrapers. This image, like most others in the group, was made early in the morning, when the raking light provided strong contrasts. The cloudless sky serves as a neutral backdrop to the dynamic urban skyline. Stieglitz regularly made photographs of the buildings that surrounded his New York apartments and galleries. Judging from the number of prints in existence, he was especially partial to this image, which was also one of the last he ever made.

Stieglitz led the vanguard to establish photography as a fine art in the United States, beginning around the turn of the twentieth century. To this end, he organized photographers, published magazines, ran galleries, and made his own creative images. Stieglitz began as a naturalistic photographer, influenced by the Englishman Peter Henry Emerson. Soon, however, he was making softly focused images and promoting the work of other pictorial photographers in his lavish quarterlies, *Camera Notes* (1897–1903) and *Camera Work* (1903–17). He created the Photo-Secession group and ran its New York gallery, "291," until World War I, when he began to embrace straightforward picture-making methods. Subsequently, he operated the Intimate Gallery, in the late 1920s, and An American Place, from 1929 until his death; both venues prominently featured the work of a small group of American modernists, including Arthur Dove, John Marin, Marsden Hartley, and O'Keeffe, his wife. During this time, Stieglitz was making both pictures of clouds (his *Equivalent* series) and portraits of O'Keeffe, two of his most important bodies of work. Late in life, he gave both his collection of pictorial photographs by others and many of his own prints to the Metropolitan Museum of Art.

This print of *From the Shelton, West* was purchased in 1983 from the Edwynn Houk Gallery, Chicago. It previously had been in a private New York collection and the possession of O'Keeffe. The MIA owns four original photographs by Stieglitz and many photogravures.

Alfred Stieglitz, American, 1864–1946
From the Shelton, West, 1935, vintage gelatin silver print
9 9/16 x 7 7/16 inches (image, sheet, and original mount),
19 13/16 x 14 13/16 inches (later mount)
No inscriptions
Gift of funds from Harry M. Drake, 83.151

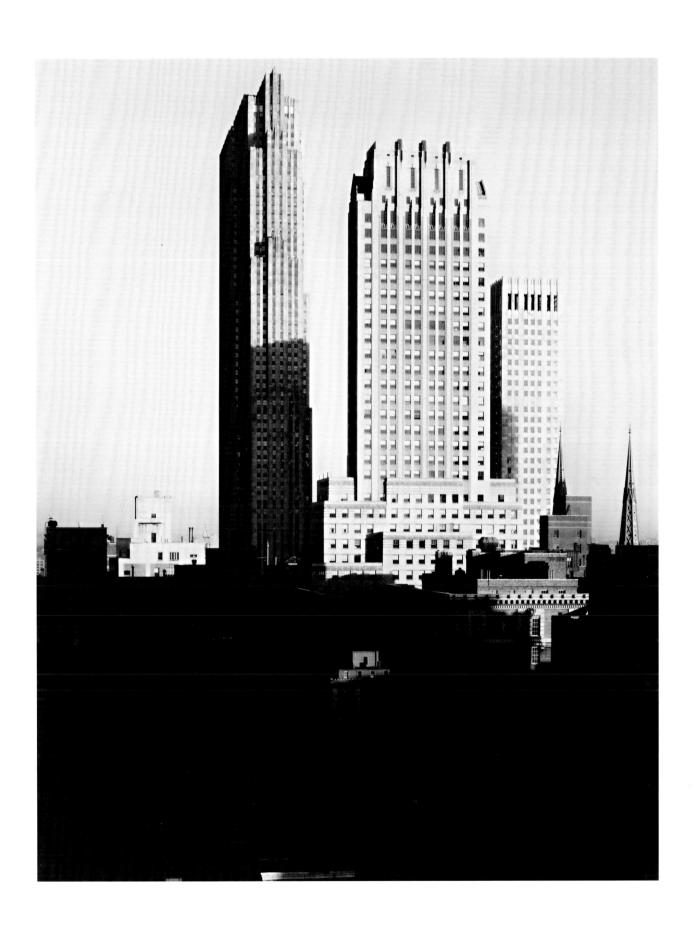

Ansel Adams

ANSEL ADAMS made at least 900 prints of this image, his most familiar, over many decades. In 1981, a mural-size version of it sold for more than any other photograph up to that time.

Adams captured this moment while returning to Santa Fe, New Mexico, after an unrewarding day photographing for the U. S. Department of the Interior. He later recalled, "Driving south along the highway, I observed a fantastic scene as we approached the village of Hernandez. In the east, the moon was rising over distant clouds and snowpeaks, and in the west, the late afternoon sun glanced over a south-flowing cloud bank and blazed a brilliant white upon the crosses in the church cemetery. I steered the station wagon into the deep shoulder along the road and jumped out, scrambling to get my equipment together." Because the sun was setting quickly, Adams had time to make only one exposure after positioning his eight-by-ten-inch camera and working without his misplaced exposure meter.

A masterpiece in the history of photography, *Moonrise* combines the grandeur of the American West with the mundane appeal of rural life. A nearly full moon illuminates the majestic Sangre de Cristo mountain range. Below are the humble structures of Hernandez, including a modest adobe church. Light was Adams's great collaborator here, not only highlighting the crosses in the cemetery but also the tops of the shrubs in the foreground to create a mass of cloudlike forms. Stretching over the horizon are actual clouds that trail across the moon. The black sky and somber tone of the entire picture seem to allude to death, as do the gravestones on the ground.

Adams's mainstream popularity is irrefutable. He was a master of the western American landscape, extensively photographing places such as Yosemite Valley, the Sierra Nevada, the Tetons, Yellowstone, and other national parks. A committed outdoorsman and conservationist, he has long been associated with the Sierra Club and its efforts to protect the environment. A technical wizard in the darkroom, he developed the Zone System, a method of maximizing the tonal range of film. In 1932, he was a cofounder, along with Edward Weston, of Group f.64, a small cadre of photographers dedicated to straight photography. In the following decades, he was instrumental in spearheading several important photographic endeavors, including *Aperture* magazine, the Friends of Photography, and the Center for Creative Photography at the University of Arizona, Tucson. Trained as a pianist, Adams liked to say that his negative was like a musical score and his print the performance.

Frederick B. Scheel, of Fargo, North Dakota, gave this print to the museum in 2007. Scheel, a serious amateur photographer, took a workshop with Adams in 1961 at Yosemite National Park, where he bought this print for forty dollars. The MIA's permanent collection contains sixty-three photographs by Adams.

Ansel Adams, American, 1902–84
Moonrise, Hernandez, New Mexico, 1941, gelatin silver print (printed 1961)
15 7/16 x 19 7/16 inches (image and sheet), 22 x 28 inches (mount)
Signature, in ink, on mount; wet stamp "PHOTOGRAPH/BY/ANSEL ADAMS/
 131–24TH AVENUE/SAN FRANCISCO/NEG. NO.___," verso; "1-SW-32"
 (negative number) and title, in ink, verso
Gift of Frederick B. Scheel, 2007.35.301

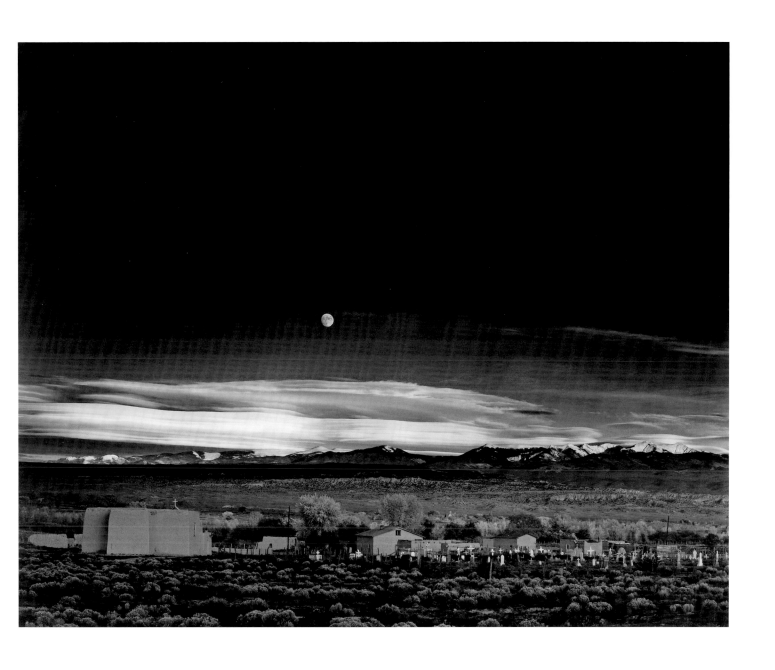

Berenice Abbott

IN 1912, the Minnesota lumberman T. B. Walker purchased large tracts of forest to expand the holdings of his Red River Lumber Company to Westwood, California, in the northeastern part of the state. Within eight years, this branch of Walker's vast enterprise was producing 175 million board feet of white and sugar pine annually. Walker's California company hired Berenice Abbott in 1943 to photograph its buildings and operations. Abbott spent ten days on this commission, which represents the only work she ever did west of the Mississippi River.

Abbott used a twin-lens reflex camera on the job, producing medium-format negatives that measured 2 1/4 inches square. She then cropped most of the images to a rectangle, and rendered them with startling detail, as is evident in the image of Shed Six. This dramatic, modernistic picture features straight lines overlapping one another and running at different angles. The roofline, ladders, pipe, pole, and clapboard siding are delineated by strong light and deep shadows. The side of the building pictured is almost beyond human scale, even though Abbott includes two men painting the expansive façade with small brushes. Abbott's graphic, black-and-white image only hints at the paint colors being used, as different areas appear in various shades of gray.

Abbott spent the 1920s in Paris, where she was an assistant to Man Ray and also ran her own portrait studio. She befriended Eugène Atget and helped salvage his life's work after his death. During the 1930s, she extensively documented New York City for the federal government's Works Progress Administration, photographing the city's buildings, bridges, and streets during a period of rapid expansion; many of these images appeared in her 1939 book *Changing New York.* Several high-school textbooks published in the 1950s and early 1960s contain examples of her scientific photography. Abbott established the photography program at the New School for Social Research, New York, but moved, in 1966, to Maine, where she lived until her death at ninety-three.

Martin G. Weinstein found a group of Abbott's photographs for the Red River Lumber Company at James and Mary Laurie Booksellers, St. Paul, in the early 1990s; no doubt they ended up here because the headquarters of Walker's company was in Minnesota. In 1993, Weinstein gave this print to the Minneapolis Institute of Arts.

Berenice Abbott, American, 1898–1991

Shed Six, for Storage of Dry Lumber, Red River Lumber Company, California, 1943, vintage gelatin silver print

13 15/16 x 19 11/16 inches (image and sheet), 16 x 20 inches (mount)

"© The Red River Lumber Co." wet stamp, and Abbott's signature, in pencil, on the mount; "#32 Shed Six (For Storage of Dry Lumber)," in pencil, and "photograph/berenice abbott/50 commerce st./ new york city" wet stamp, verso

Gift of Lora and Martin G. Weinstein, 93.70.72

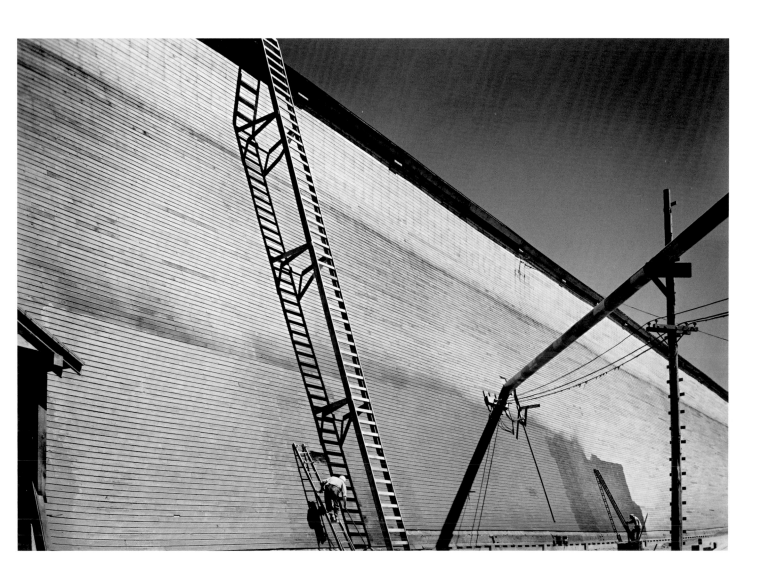

Bill Brandt

BILL BRANDT situated this nude model in a room in the Hampstead borough of London, home to many artists and writers around the middle of the twentieth century. Perversely, its gloomy atmosphere defies the celebratory mood of the country on the day it was made: May 8, 1945, when Allied forces in World War II declared victory. This print, with its compressed scale of gray tones, typifies the somber look of Brandt's images until the 1970s, when he began reprinting his old negatives with much more contrast and grain. While his later prints pack greater graphic punch, the earlier ones are characterized by subtlety and mystery.

The seated blond figure in this image seems to loom too large for the room she nonchalantly inhabits. Like the oversized Alice in Wonderland, she appears in a foreign environment that offers few escapes. Brandt appreciated the movie *Citizen Kane,* and frequently used dramatic lighting in his photographs of nudes, producing images that resembled film stills. This one includes a multitude of shadows—cast by the figure, the chair, the bed, a piece of furniture just outside the frame on the left, and an unknown object in the upper right corner.

Brandt's alternate title for this image was *The Policeman's Daughter.* He reportedly was fascinated with the policeman as an authority figure, and sometimes used a small, concealed Kodak that he called his "policeman's camera." This image may have fulfilled one of the photographer's sexual fantasies by alluding to Algernon Charles Swinburne's unpublished erotic novel *La Fille du Policeman*, about the daughter of an officer of the law who is raped.

Nudes comprise one of Brandt's most important bodies of work. He began shooting them in 1944, just a year before making *Hampstead, London,* one of his earliest and most celebrated images. Shunning the contemporary tendency to situate models in the studio, Brandt instead preferred to photograph them in residential settings, thus imbuing his pictures with a greater sense of reality. Eventually, he ventured outdoors, where he frequently placed his models on England's rocky shoreline. In 1961, a year after he ceased photographing the female form, he issued *Perspective of Nudes*, his most important book.

A native of Germany, Brandt spent time in Paris as a photography assistant to the artist Man Ray. He settled in England in 1929, and in the mid 1930s, began working for magazines, contributing regularly to *Lilliput* and *Harper's Bazaar.* When London was heavily bombed by the Germans in 1940, he photographed the human drama in the city's packed air-raid shelters, on assignment for the government's Ministry of Information. In addition to nudes, Brandt regularly made photographs in England of the harsh landscape, urban structures, and notable personalities. Mingling with both workers and the wealthy, he also made a photographic study that implicitly criticized England's class consciousness.

The MIA, which owns thirty prints by Brandt, purchased this photograph in 1985 from the Edwynn Houk Gallery, Chicago, which represented the Brandt estate.

Bill Brandt, English (born Germany), 1904–83
Hampstead, London, 1945, vintage gelatin silver print
8 15/16 x 7 11/16 inches (image), 10 x 7 15/16 inches (sheet)
"BILL BRANDT" wet stamp, verso
Mr. and Mrs. Patrick Butler Fund, 85.88

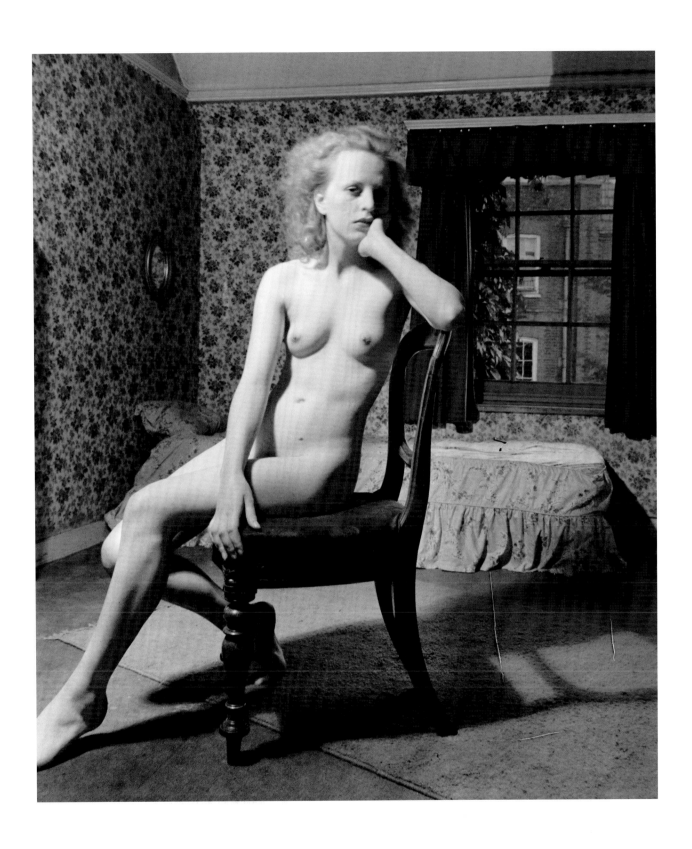

Val Telberg

VAL TELBERG, a Russian immigrant, made this haunting self-portrait at the window of his apartment on St. Mark's Place, on New York's Lower East Side. He strategically placed himself in heavy shadows to create a surrealistic image that alludes to both the multiplicity of personality and the rigors of the Machine Age. One shadow so perfectly bisects his face that we see the subject in both profile and three-quarter view. Is Telberg suggesting he has a split persona or that he was capable of viewing the world from multiple perspectives? The dominant shadow, apparently cast by a tripod, hovers over him like a gallows or some other life-threatening mechanism. Perhaps he was merely acknowledging the camera's dominance in his own life or the increasing prevalence of mechanical devices in the world in general.

Significantly, Telberg closed his eyes during the exposure. The resulting effect evokes dreaminess and even the possibility of death, given the dark tonalities of the image and the suggestion of a threatening apparatus. A known variant of this image shows the subject with his eyes wide open, looking somewhat terrified, but this photograph, with its somber grays, is more mysterious and visually coherent. Telberg made a disoriented image by printing it at an exaggerated angle, as evidenced by the black triangle in the lower right corner.

The photographer was born Vladimir Telberg-von-Teleheim in Moscow. Six years after moving to New York, in 1938, he was devoting most of his time to photography, and began superimposing his negatives, in order to create montaged, solarized, and kaleidoscopic images. He most frequently combined nudes, body parts, and architectural elements, rendered in both positive and negative values. In 1966, after not photographing for about a decade, he resumed making multi-image photographs, but on a much larger scale. In the 1970s, he turned his attention to multi-media productions, integrating sculpture, photography, and other art forms.

The MIA bought this print and one other by Telberg in 1981 from the New York dealer Laurence G. Miller, the photographer's representative.

Val Telberg, American (born Russia), 1910–95
Self-Portrait, St. Mark's Place, c. 1947
Vintage gelatin silver print
13 7/8 x 11 inches (image and sheet)
Signature, title, and date, in pencil, verso
Ethel Morrison Van Derlip Fund, 81.97.1

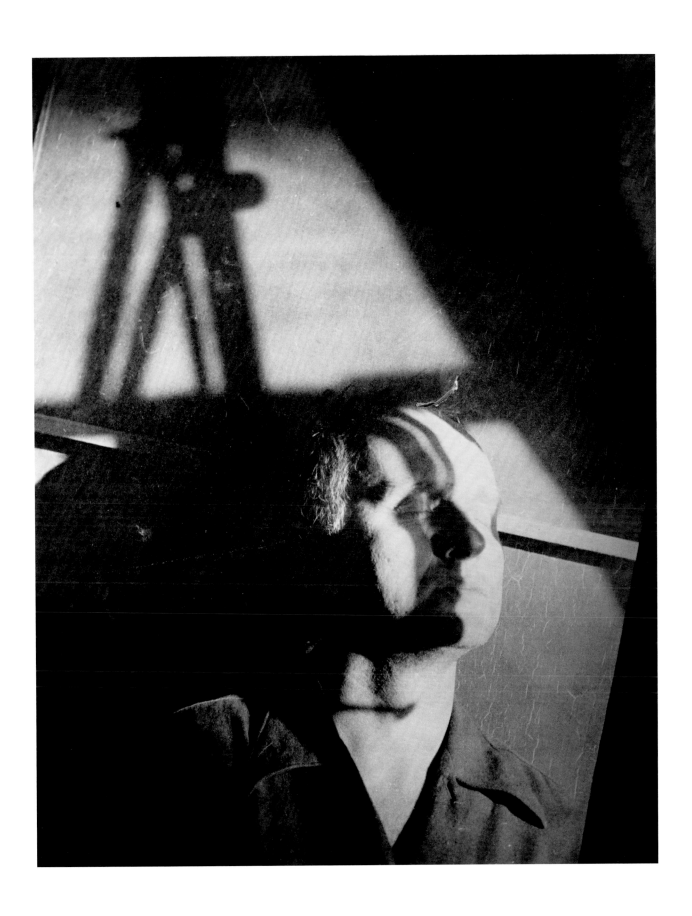

Todd Webb

TODD WEBB made this entertaining panorama around noon one day in 1948, documenting the west side of Sixth Avenue between Forty-third and Forty-fourth Streets, in midtown Manhattan. On this typical block were more than a dozen small businesses, selling cigars, luggage, records, art materials, books, and men's clothing, plus a few restaurants and a health-drink shop. Webb was undoubtedly drawn to this string of facades by the variety of period signs, from hand-painted to slick neon. In contrast to today's reliance upon retail branding, some of these stores do not even have proper names, relying simply on the products sold to attract customers.

Webb used the street curb as the baseline for his photograph; the resulting dark line along the bottom of the picture seems like a shelf supporting a three-dimensional miniature scene. The sidewalk is animated with about fifty pedestrians, most of them men wearing hats and topcoats and walking toward the right. Of the two vehicles parked on the street, one is an empty taxicab—a ride in which, at the time, cost only twenty cents for the first quarter mile.

In the decade after Webb made the picture, it received widespread attention. It was included in an exhibition at the Museum of Modern Art, was installed as a four-by-twenty-four-foot print at the Brussels World's Fair, and was the subject of a story in the April 1954 issue of *Modern Photography*. The article reproduced the entire image, spread over six pages, plus pictures illustrating how Webb took the photograph and mounted finished prints of it with an iron on Masonite board. His text provided technical information—such as the fact that he used a four-by-five-inch Graflex camera—and revealed that it took him only a half-hour to photograph the block. He concluded by saying, "A study of the history of photography will show few really novel concepts. I felt rather smug at having made this panel of Sixth Avenue." Today, none of the subjects in the photograph survives. The block was totally reconfigured a number of years ago, and now, appropriately enough, houses the International Center of Photography.

The photographer, born Charles Clayton Webb III, originally worked as a stockbroker and gold prospector. He began photographing while living in Detroit in the late 1930s. Webb was a photographer in the United States Navy during World War II, after which he moved to New York City, where he photographed for *Fortune* and Standard Oil. During the 1940s and 1950s, his personal work comprised mostly street scenes of storefronts and pedestrians in New York and Paris, where he lived for a time. In the 1960s, he resided in New Mexico, where his primary subject was Georgia O'Keeffe.

This panorama was given to the museum in 1984 by Martin G. Weinstein, then an MIA trustee and now the owner of a gallery in Minneapolis. Weinstein, a native New Yorker, was amused to see his first name prominently displayed on one of the shops. He acquired the photograph from the San Francisco dealer Stephen Wirtz, who obtained it directly from Webb.

Todd Webb, American, 1905–2000
Avenue of the Americas, New York City, 1948
Eight gelatin silver prints
10 5/8 x 83 5/8 inches (image), 11 x 84 9/16 inches (mount)
Signature and date on mount
Gift of Lora and Martin G. Weinstein, in memory
 of Joseph A. Weinstein, 84.125.4

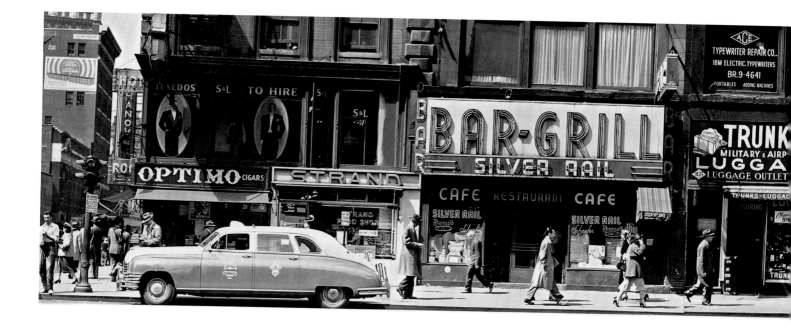

Frederick Sommer

LIVIA is one of the most recognizable images produced by Frederick Sommer, who made only a few other portraits. The subject, the daughter of Sommer's neighbor, actually was named Lydia; Sommer used the name Livia apparently in reference to the wife of the first Roman emperor, Caesar Augustus. Knowing that Livia was a powerful woman, notorious for her seductive and deadly tactics, the photographer slyly imbued his innocent-looking subject with a cunning quality.

Young Lydia is, for the most part, presented as a sweet child, a model of youthful purity. She wears a crisp white dress and folds her tiny hands prayerfully over her chest. Her chaste pose might be interpreted as an appeal to a higher power, had Sommer not hinted at less-than-innocent elements in his subject. Lydia's eyes, for example, are somewhat unsettling; unusually large, they gaze slightly upward, as though avoiding contact with the viewer. In addition, the background against which she stands appears to be paper printed with various wood-grain patterns that is peeling away from its support; the effect is one of deterioration and decay. It is this contrast between perceived good and something quite sinister that gives the image much of its hypnotic power.

Sommer was born in Italy and grew up in Brazil, where he initially intended to become a landscape architect. He immigrated to the United States in 1923, but then studied art and philosophy abroad for many years. After returning to the United States in 1931 and settling permanently in Prescott, Arizona, he began seriously to pursue photography. He met and was influenced by Alfred Stieglitz and Edward Weston and the artists Max Ernst and Man Ray. From the 1950s to the 1970s, he taught workshops around the country. Called the "Joseph Cornell of photography," Sommer produced his work in the isolation of Arizona, where he made abstract photograms and photographed the desert landscape and still lifes of animal and doll parts. He also created surrealist drawings, watercolors, and collages.

Livia was purchased in 1989 from the New York dealer Alan Klotz. The previous owner was a senior editor at *U.S. Camera*, who acquired it directly from Sommer for reproduction in the magazine's 1950 annual. The photographer reportedly told the editor this was an exhibition print, but it has since acquired a slight purple cast, suggesting it was insufficiently processed. This is the only photograph by Sommer in the MIA's collection.

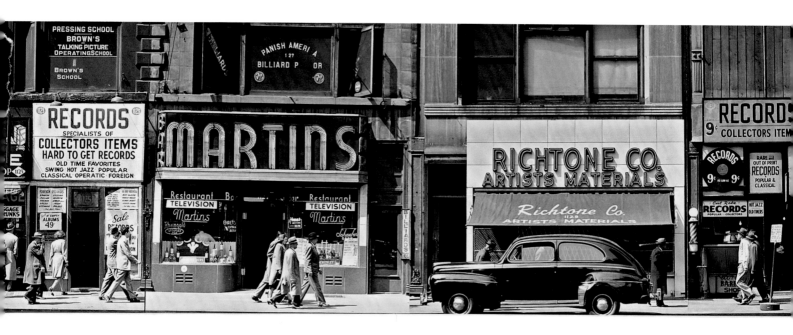

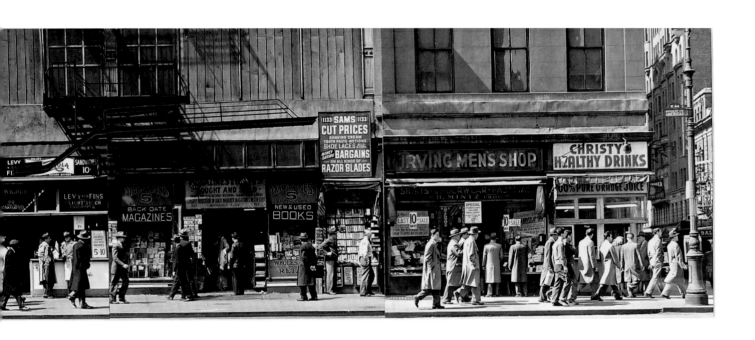

Frederick Sommer, American (born Italy), 1905–99
Livia, 1948, vintage gelatin silver print
7 5/8 x 9 3/8 inches (image and sheet), 9 x 10 1/2 inches (mount)
No inscriptions
William Hood Dunwoody Fund and gift of funds from
 Jud and Lisa Dayton, 89.84

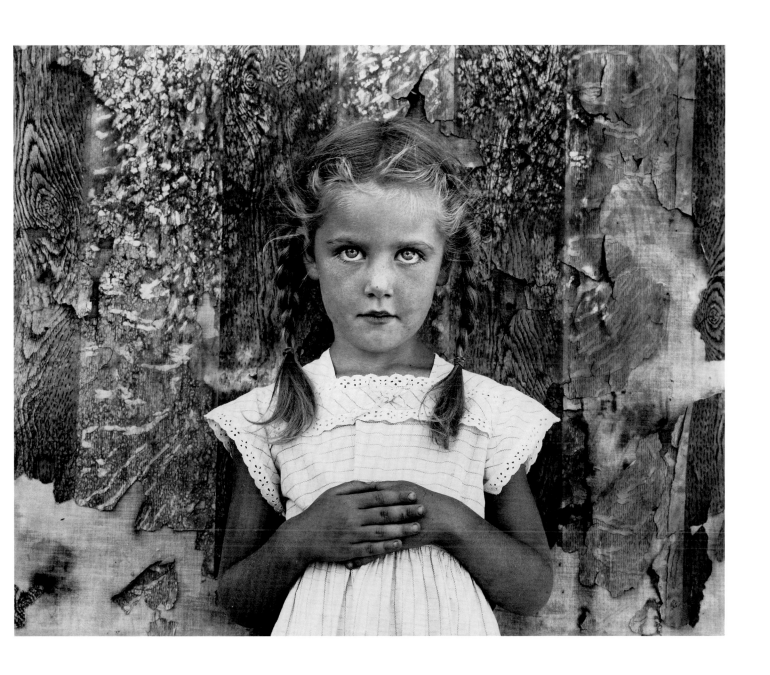

Gordon Parks

THE NOVEMBER 1, 1948, issue of *Life* featured this photograph as the lead image in a ten-page picture story by Gordon Parks titled "Harlem Gang Leader." The gregarious Parks, an African American himself, gained Red Jackson's confidence and spent four hectic days photographing the youth and his gang. Called the Midtowners, they were based on 119th Street, in the center of Harlem, New York City's predominantly black community. The seventeen-year-old Jackson, nicknamed for his red hair, had become the leader of the group two years earlier, after his predecessor was jailed for a shooting.

Parks made this image soon after Jackson had viewed the scarred body of a fellow gang member at a Harlem mortuary, a scene also depicted in the picture story. Upon leaving, Jackson encountered rivals on the street, and sought refuge in an abandoned building. He is presented here peering out a broken window, a haunting metaphor for his shattered life. Parks effectively used the available illumination to highlight Jackson's physical features, hand-rolled cigarette, and loose garments. This soft, gentle lighting contrasted sharply with the real-life, potentially violent situation in which Jackson found himself.

Parks provided a well-rounded portrait of his subject in the *Life* photographs. He captured Jackson fistfighting and frisking another kid for a gun. But he was also pictured spending happy domestic time with his mother and brother and slow-dancing with his girlfriend. More optimistically, Parks photographed a plainclothes policeman and a neighborhood minister serving as mentors to Jackson. His most uplifting image was of Jackson wearing a suit after participating in a youth program to combat Harlem violence.

Parks enjoyed a long career as a photographer, film director, writer, and composer. He got his start as a photographer in St. Paul, Minnesota, his home for a few years as a teenager, where he made fashion shots for an upscale clothing store. During World War II, he briefly worked for the federal government's Farm Security Administration and then for the Office of War Information. After shooting for *Vogue* for four years, he became the first black staff photographer at *Life*, in 1948. There he produced numerous picture stories and shot many portraits (Malcolm X, the black Muslim leader, was a frequent subject) until 1972, when the magazine ceased weekly publication. His most well-known movie was *Shaft* (1971), which launched the genre of blaxploitation films. During the 1980s and 1990s, Parks's work became more reflective, taking the form of memoirs, poems, novels, and musical scores.

The MIA purchased this print and seven others by Parks at Sotheby's New York auction on November 1, 1988 (lot 212). They came from the estate of Peter Pollack, the first curator of photographs at the Art Institute of Chicago and author of *The Picture History of Photography* (1958).

Gordon Parks, American, 1912–2006
Red Jackson, Harlem Gang Leader, 1948, vintage gelatin silver print
19 5/16 x 14 3/4 inches (image and sheet)
"LIFE PHOTO/BY/GORDON PARKS" wet stamp, verso
Christina N. and Swan J. Turnblad Memorial Fund, 88.72.2

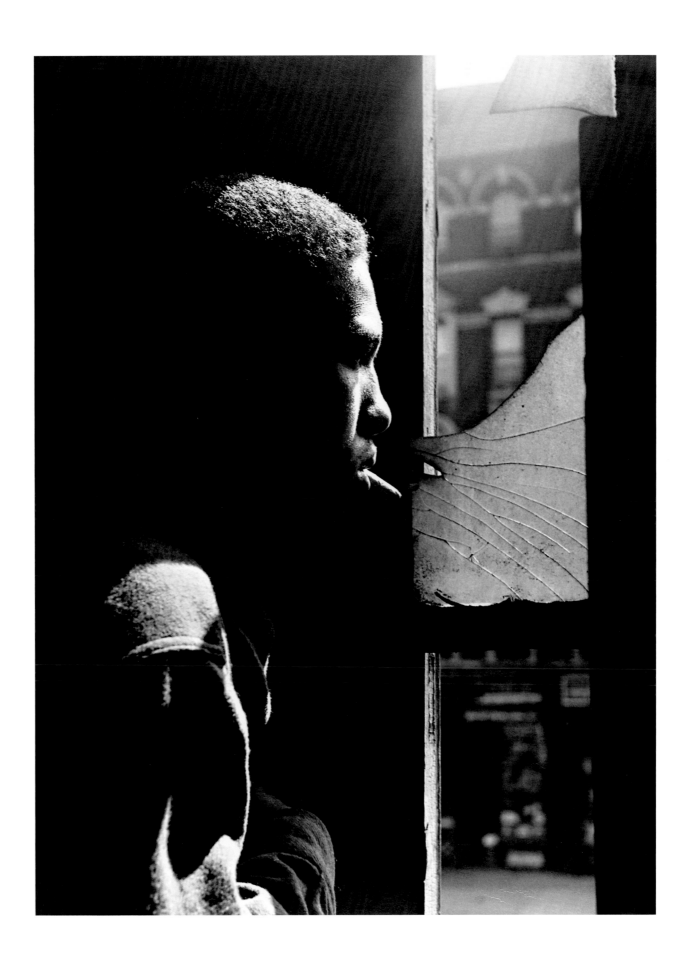

Minor White

SONG WITHOUT WORDS is one of Minor White's most successful early sequences of photographs. Created in 1948, it consists primarily of photographs White made along the Pacific coastline near San Francisco. The twenty-four images are arranged in a seemingly random nonnarrative manner that flows as rhythmically as the waves that appear in many of the pictures.

Sun in Rock is the lone image from the sequence to which White gave a specific title. The picture demonstrates his interest in making photographs that were suggestive, spiritual, and otherworldly. He positioned his camera at an elevated spot, looking down upon swirling water, breaking waves, and large rock formations, which are so dark they lose most of their texture and merge with their own shadows, becoming indeterminate craggy shapes. True to the title of the image, bright sunlight is reflected in water pooled on the surface of one rock. The result is so intensely white that it suggests a searing source of natural energy. It may represent either a life-giving force or one that is merciless and destructive.

White often organized his images into sequences, a format few photographers attempted. He produced his first sequence in 1942 and his last almost thirty years later; these "cinemas of stills," as he called them, comprised from ten to thirty pictures. Both the order of the images and the entirety of each ensemble were personally meaningful, and he accompanied most of those made in the 1940s with introspective text. White wrote on the back of the mount of the first print of this set of *Song Without Words*, "So like you have these images become. They have usurped reality." During the 1950s, he began to make sequences of images that were more abstract and symbolic. White constantly edited and reordered his sequences, wishing to create different interpretations of his pictures. In 1950, he reduced *Song Without Words* to a fifteen-print group, which he called simply *These Images*.

One of the most influential American photographers to emerge in the middle of the twentieth century, White saw the camera as a "metamorphosing machine" that could delve beyond surface appearances to reveal life's deeper meaning. He was born and educated in Minneapolis; after college, he moved to Portland, Oregon, where he began his career as a photographer. After serving in World War II, he settled in San Francisco, concentrating on landscape images that combined the descriptive with the suggestive. He adopted Alfred Stieglitz's concept of artistic photographs as tangible representations of their creator's emotions and spiritual convictions. White's interest in and study of Zen Buddhism, Gestalt psychology, and Gurdjieff philosophy all affected his lifestyle, teaching, and photographs. In 1952, he helped found the magazine *Aperture*. White's magnum opus, *Mirrors Messages Manifestations,* appeared in 1969; it was both an artist's book and his autobiography. He supported himself most of his life as a teacher, influencing hundreds of photography students in workshops and at established schools. He began his academic career at the San Francisco Art Institute in 1946, then moved to the Rochester Institute of Technology in the mid 1950s, and finally taught at the Massachusetts Institute of Technology, from 1965 to 1974.

This set of *Song Without Words* was originally in the collection of the Australian photo historian Keast Burke and was sold to the museum by the Robert Mann Gallery, New York, in 2001. According to Peter C. Bunnell, White printed seven sets of this sequence in 1948, one of which was exhibited at the San Francisco Museum of Art later that year.

Minor White, American, 1908–76
Song Without Words, 1948, sequence of 24 gelatin silver prints
Approx. 3 1/2 x 4 1/2 inches, or reverse (images and sheets),
 8 1/4 x 10 inches, or reverse (mounts)
"Song w/o [or Without] Words/Minor White [signature]," in pencil, verso
Ethel Morrison Van Derlip Fund, 2001.180.1-24

Sun in Rock (San Mateo County Coast, California), October 12, 1947

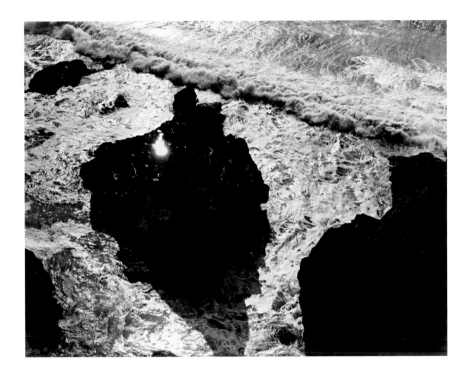

Louis Faurer

NEW YORK'S TIMES SQUARE was a family-friendly urban hub after World War II, full of movie theaters, muscular American-made automobiles, throngs of pedestrians, and a riot of lights. While the Cold War was heating up, much of America enjoyed a sense of complacency and naïve optimism. At the same time, a small group of renegade photographers took to the streets, making images with Leica's new small-format (35mm) camera and relying only on available light. Among America's leading exponents was Louis Faurer, a new arrival to New York.

Times Square was one of Faurer's favorite settings—often at night, when there was lots of activity and the dazzling display of lights created strong contrasts. Not surprisingly, Faurer, who previously had drawn posters and painted signs, was especially fascinated by the area's massive billboards. He never posed his subjects, and he captured the six members of this family in a stance they themselves assumed. Faurer shot this image in color as a Kodachrome slide, and made this lone black-and-white print from his original transparency. Its fairly narrow range of heavy gray tones is typical of monochrome images made from color materials.

Faurer created most of his personal work in the late 1940s and early 1950s in New York. Professionally, he made fashion and editorial photographs, beginning at *Junior Bazaar* in 1947; other magazines that ran his images over the next twenty years were *Look, Glamour, Mademoiselle, Seventeen*, and *Vogue*. In the 1960s, he experimented with 16mm film and worked as a set photographer for a few Hollywood movies. After living in Paris and working for French magazines in the early 1970s, he returned to New York in 1974, and began teaching at Parsons School of Design and lecturing elsewhere. A serious traffic accident terminated his photographic work in 1984.

The MIA purchased *Family, Times Square, New York City* from New York's Light Gallery in 1981, during the brief time it represented the photographer; subsequently, Faurer had limited gallery representation. The museum owns twenty-two photographs by Faurer.

Louis Faurer, American, 1916–2001
Family, Times Square, New York City, 1949-50, vintage gelatin silver print
8 7/8 x 13 9/16 inches (image and sheet), 14 x 16 inches (recent mount)
Signature and "1948" [*sic*], in pencil, verso; "b + w from a color transp.—unique,"
 in pencil, at lower left corner of mount
Ethel Morrison Van Derlip Fund, 81.98.2

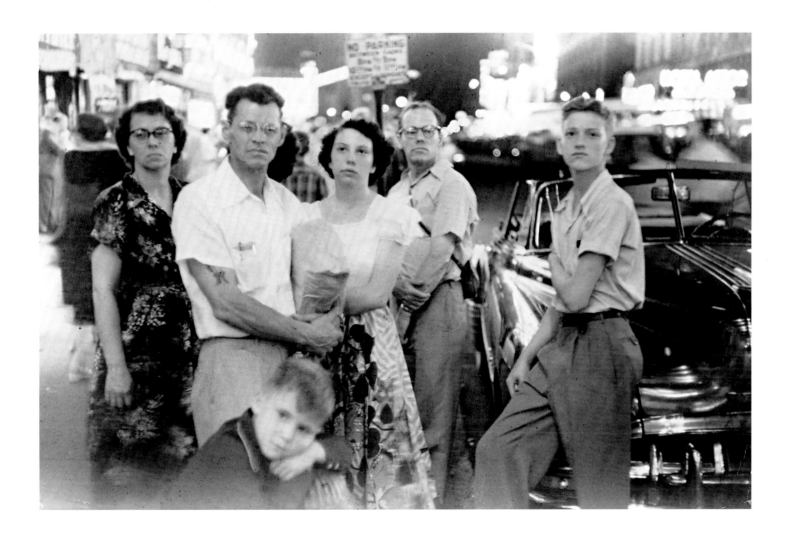

Consuelo Kanaga

THIS IMAGE, also known as *The Question*, shows a black mother and her son in bright Florida sunlight, their heads virtually silhouetted against a blank sky. Looming large in the frame, they assume an almost sculptural quality. While the woman looks down, seemingly discouraged or at least pensive, the boy gazes up at her, as if for guidance or an answer.

Consuelo Kanaga photographed this pair while on her last professional trip to the South. The resulting images of African Americans were her most rewarding body of work and the one for which she is best known. Kanaga usually turned her camera on only one or two people at a time, and the resulting images capture southern blacks in the era of segregation. In order to give them a strong graphic quality, Kanaga posed her subjects and formally organized her images, as is evident here.

Kanaga's first job was as a photographer for the *San Francisco Chronicle* in the late 1910s; at the time, this was an unusual profession for a black woman. During the 1920s, she traveled and photographed in New York, Europe, and northern Africa. Returning to San Francisco, she established a portrait studio in the early 1930s and became a member of Group f.64, which included fellow straight photographers Ansel Adams and Edward Weston. In 1935, she moved to New York, where she became involved in radical politics, joined the Photo League, and eventually opened a studio. Kanaga supported herself by completing assignments for mainstream magazines like *Good Housekeeping* until 1950, when she moved to Westchester County and essentially stopped photographing. However, the Civil Rights movement attracted her attention and support in 1964, when she briefly returned to photography—making pictures of its impact on residents of Georgia.

This print is one of three by Kanaga in the MIA's permanent collection. It was purchased in 2002 from the Weinstein Gallery, Minneapolis, which acquired it from the Howard Greenberg Gallery, New York.

Consuelo Kanaga, American, 1894–1978
Mother and Son, Florida, 1950, vintage gelatin silver print
9 5/8 x 7 9/16 inches (image and sheet), 16 x 12 inches (mount)
Signature, in pencil, on the lower right corner of mount
Alfred and Ingrid Lenz Harrison Fund, 2002.152.1

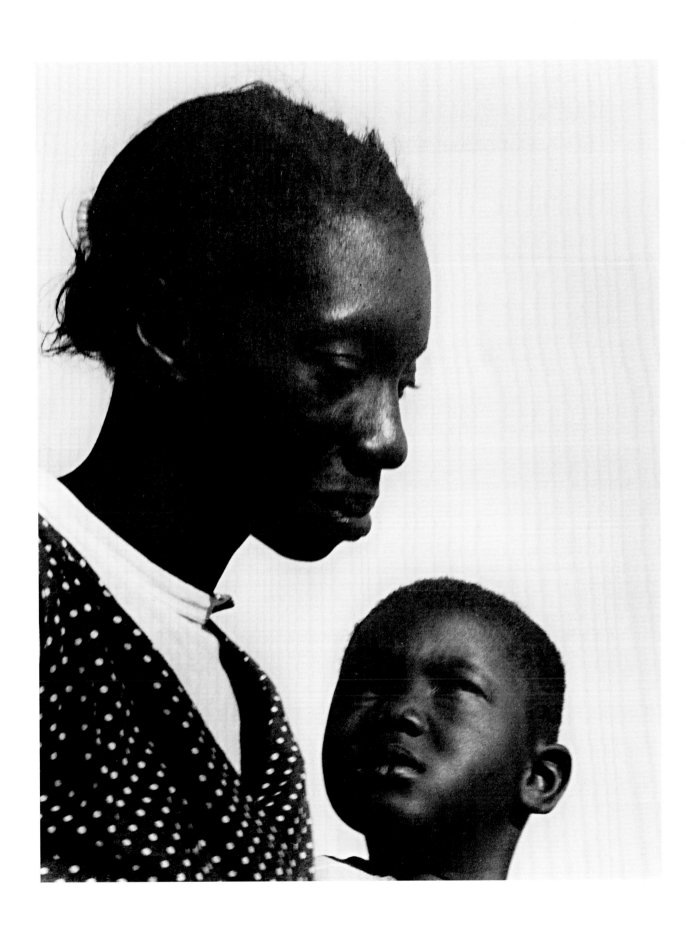

Aaron Siskind

THIS IMAGE is perhaps the most elegant of those Aaron Siskind made of stone walls on Martha's Vineyard. Photographed in the 1950s, long before the Massachusetts island had become a summer haven for the wealthy, this picture reveals Siskind's abiding interest in finding abstraction in everyday reality. The stones in the image certainly are recognizable as mammoth rocks, yet the photographer has rendered them as ragged black shapes, interspersed with equally amorphous masses of white. Negative and positive spaces are dramatically juxtaposed in this brutally graphic image. At the same time, the picture has an almost lighthearted quality, as the rocks appear to levitate and balance—impossibly—on top of one another. Interestingly, Siskind was simultaneously working on another group of pictures, titled *Pleasures and Terrors of Levitation*, that captured images of contorted airborne divers.

Siskind is best known for his close-up photographs of walls bearing the ravages of time as well as paint, graffiti, and posters. Using straightforward photographic methods, he created seemingly abstract pictures that ventured far beyond the documentary. His gestural images, which often acknowledged his friend Franz Kline and influenced the paintings of William de Kooning, clearly reflected the abstract expressionism of the 1940s and 1950s.

Born in New York, Siskind lived and worked there for the first half of the twentieth century. He taught English in the public schools for fifteen years, and became active in the Photo League in the 1930s, directing an extensive project documenting the poverty of Harlem's residents. Siskind moved to Chicago in 1951 to begin twenty years of teaching photography at the Illinois Institute of Technology's Institute of Design, where he and Harry Callahan nurtured a generation of creative photographers. He finished his teaching career at the Rhode Island School of Design, Providence, in the early 1970s.

The Minneapolis Institute of Arts purchased *Martha's Vineyard III* in 2001 from Joan Gordon, who acquired it from Siskind when she was his student. It is one of thirty-two Siskind photographs in the permanent collection.

Aaron Siskind, American, 1903–91
Martha's Vineyard III, 1954, vintage gelatin silver print
13 1/4 x 16 7/16 inches (image, sheet, and first mount),
 20 1/8 x 23 15/16 inches (second mount)
No inscriptions
Alfred and Ingrid Lenz Harrison Fund, 2001.46

W. Eugene Smith

THIS IMAGE is one of the most iconic from W. Eugene Smith's mammoth project documenting Pittsburgh in the mid 1950s. In it, a young black boy clings to the top of a sign at the corner of Colwell and Pride Streets in an impoverished section of the city. The child probably climbed the pole for entertainment, yet he exudes little joy or sense of accomplishment, instead turning his face from the camera and holding almost desperately onto the sign. The name of one of the streets is, of course, bitterly ironic, given the derelict surroundings, and the image's dark tones underscore a sense of suppression and hopelessness.

This image is one of many Smith made in Pittsburgh in which evocative street signs are prevalent elements; among the others he photographed were Breed, Climax, Dream, Loyal, Friendship, Mercy, Progress, and the corner of Ophelia and Hamlet Streets. Unlike *Pride Street*, most of these images lacked human subjects and, as a result, convey a message that the street names are cruelly mocking.

Historian and editor Stefan Lorant commissioned Smith in 1955 to supply 100 photographs for a chapter in an upcoming book to celebrate Pittsburgh's bicentennial. Lorant expected Smith to spend about a month in the city, but the photographer stayed for an entire year (and even returned twice afterward). Ultimately, he exposed more than 15,000 negatives in his determination to capture the essence of this idiosyncratic three-river city—its industry, culture, architecture, terrain, and people. After Smith submitted the requisite number of pictures to Lorant, the photographer subsequently secured two successive Guggenheim grants and help from his picture agency, Magnum, to pursue his own goal of producing a book devoted to Pittsburgh. Smith worked for more than two years with up to 2,000 prints, constantly editing and reordering them, but he never found a publisher, largely because he insisted on writing the text himself and having full control over the layout of the pictures.

In 1958, however, the editors of *Popular Photography* magazine agreed to Smith's terms, and published a selection of the work as a picture story in their *Photography Annual 1959*. Smith filled thirty-six pages with nearly ninety images and accompanying text, which began, "A personal interpretation— Pittsburgh, like any city, is a turbulent debate, teeming evolution within the equilibrium of paradox." He titled the essay "Labyrinthian Walk," perhaps suggesting the difficulty of navigating the publishing world, as well as Pittsburgh itself. Smith unified each two-page spread with a theme, and included seven of his street-sign pictures, but not *Pride Street*.

Smith is considered by many to be the most important American photojournalist of the twentieth century. His first published photographs appeared in his hometown newspaper in Wichita, Kansas, when he was still a teenager. In 1937, he moved to New York, where he began working for *Newsweek*, and a few years later, for *Life*. During World War II, Smith photographed many of the major Asian battles and was seriously wounded. He produced many significant photographic essays for *Life* between 1947 and 1954, the magazine's heyday; he frequently quarreled with its editors, however, over control of his pictures, and severed ties with the magazine permanently after it published his 1954 essay on Dr. Albert Schweitzer. After completing his ambitious Pittsburgh project, Smith photographed prominent jazz musicians for their record covers. Late in life, he worked in Japan, making pictures that revealed the devastating effects of industrial pollution on the inhabitants of Minamata; the results of this undertaking were published as a book in 1975.

The museum owns thirty photographs by Smith. *Pride Street, Pittsburgh* was purchased in 2004 from Charles A. Hartman, a dealer in Portland, Oregon. Its provenance is: Smith, to a fellow exhibitor in the 1955 exhibition "The Family of Man" (Museum of Modern Art, New York), to the son of this photographer (by inheritance), to an unnamed dealer.

W. Eugene Smith, American, 1918–78
Pride Street, Pittsburgh, 1955, vintage gelatin silver print (printed 1957 or earlier)
13 7/16 x 8 15/16 inches (image and sheet), 20 x 16 inches (gray mount)
Wet stamps, verso: "COPYRIGHT AND CREDIT NOTICE: THIS PHOTOGRAPH MAY/NOT
 BE COPIED, PUBLISHED, OR EXHIBITED WITHOUT/WRITTEN CONSENT AND
 AGREEMENT TO THE TERMS OF/© W. EUGENE SMITH" and "134 OLD POST ROAD
 NORTH/CROTON-ON-HUDSON, N. Y./CROTON 1-4890"
Alfred and Ingrid Lenz Harrison Fund, 2004.138

Robert Frank

WHILE VISITING A FRIEND in Hoboken, New Jersey, Robert Frank shot this image on March 28, 1955, the day that city was celebrating its centennial. Not surprisingly, it captures a portion of the American flag, an object that would soon become a recurring motif in Frank's work. Instead of enthusiastically acknowledging the patriotic hoopla of that day—and of the 1950s, in general—this image comments caustically on the American scene. A brick façade separates the two figures, who stand behind closed windows; shrouded in darkness, they appear isolated from each other and the rest of the world. Tellingly, Frank did not photograph the parade's marching bands, gaudy floats, or happy faces of spectators, but instead turned his camera on these women, far removed—at least in spirit—from the festivities down on the street.

Hoboken, located just across the Hudson River from Manhattan, is the birthplace of baseball, Frank Sinatra, and even Alfred Stieglitz, but Frank apparently saw no civic pride in the city the day he was there. The photographer, who rarely speaks about his work, indicated at one time that the figures in the image were "sort of hiding" and that he considered his finished print "a threatening picture."

In 1955 and 1956, Frank received two consecutive Guggenheim Fellowships to photograph America through his sharp, immigrant eyes. He frequently took short trips out of New York, and then bought a 1950 Ford coupe for a nine-month drive along circuitous routes to and from California. Immersed in the emerging car culture of the 1950s, he photographed gas stations, drive-in theaters, diners, bars, car shows, auto factories, and the highway itself. For Frank, the malaise of the American people was palpable and fairly begged to be conveyed photographically. The best of the resulting pictures formed a body of work he published as *The Americans*, now considered a masterpiece among twentieth-century photographic books.

First issued in Paris in 1958 by Robert Delpire as *Les Américains*, the book featured eighty-three of Frank's biting images reproduced in rich photogravure, with a cover design by Saul Steinberg and sociological text by numerous authors. Frank chose *Parade—Hoboken, New Jersey* as the first image in the book, followed by another from the same event that shows city fathers in top hats behind a flaglike banner. In fact, pictures that include flags appear throughout the book, serving as a visual motif.

The next year, 1959, New York's Grove Press published a redesigned American edition with blank pages instead of text opposite the reproductions. The Beat poet Jack Kerouac provided the only copy, a short, stream-of-consciousness introduction that included the following intentionally misspelled remarks: "Anybody doesnt like these pitchers dont like potry, see? Anybody dont like potry go home see Television shots of big hatted cowboys being tolerated by kind horses…. To Robert Frank I now give this message: You got eyes." *The Americans* was uniformly panned in the photographic press. Reviewers recoiled at Frank's pessimistic view of America and the implication, suggested by the book's title, that the images were representative of the entire society. Despite harsh criticism, *The Americans* became a highly influential book, revered for both its incisive images and their eloquent order. It has been reprinted numerous times, and issued in Germany and Italy.

The MIA bought this print of *Parade—Hoboken, New Jersey* in 1984 from LIGHT Gallery, New York. It features crisp, punchy tones, and reportedly was printed by the artist.

Robert Frank, American (born Switzerland), 1924
Parade—Hoboken, New Jersey, 1955, gelatin silver print (printed c. 1968)
12 7/8 x 19 inches (image), 15 7/8 x 19 7/8 inches (sheet)
No inscriptions
Robert C. Winton Fund, 84.104

Robert Frank

THIS IMAGE shows four Native Americans pondering the covered victims of a fatal auto accident on Route 66. Frank encountered this scene during his 1956 cross-country trip to California. The highway traversed a part of the large Navajo Nation Indian Reservation in the northeast corner of Arizona, a place where white folks rarely stopped. Three of the four dejected subjects in this image peer down at a large blanket that presumably covers more than one body. The man on the right prayerfully folds his hands, while the others brace themselves against the cold and snow flurries.

Frank was sensitive to the power of the automobile, and more than once associated cars with death in his imagery. In his book *The Americans* (1959), *Car Accident* is directly preceded by a photograph of a parked automobile covered with a tarp, presumably to protect it from the California sun and falling palm fronds. This shrouded vehicle directly references the covered bodies that appear in *Car Accident*. Frank included elsewhere in the book another image of the aftermath of a highway accident. This one pictures three small metal crosses on the side of U.S. 91 in Idaho, planted in memory of three fatalities. Streaming down on them is a beam of sunlight, suggesting a heavenly blessing.

The MIA's print of *Car Accident* has more image area than every reproduction of it found to date. The most noticeable difference is along the top edge, where, in addition to the roofline of the house on the right, a black spot appears in the sky. Frank usually cropped out this unsightly spot, which resulted from a defect in the negative's emulsion, but it appears eerily like a black sun hovering over this mournful scene. There is also more intact image area along the other edges. Frank rendered the entire scene in flat, gray tones, reflecting both the gloomy weather and the nature of the event.

Frank immigrated to the United States in 1947 and quickly found work photographing for *Harper's Bazaar*. After shooting fashion spreads for about five years, he turned to freelance portraiture and accepted assignments from other magazines. The work that appeared in *The Americans* and the photographs he made while riding a New York City bus were his last still pictures. Turning to filmmaking, he released *Pull My Daisy* in 1959, a largely improvisational movie that included Allen Ginsberg and other Beat artists in its cast. Over the next decades, he produced numerous films and videos, most of which featured intentionally unpolished production techniques and personal or autobiographical themes. His 1972 film *Cocksucker Blues*, created with Minneapolis native Danny Seymour, achieved the most notoriety, due to its subject—the Rolling Stones on tour—and its limited availability. Since the 1980s, Frank occasionally has photographed again, shooting, among other things, the 1984 Democratic National Convention.

The MIA bought *Car Accident* in 1988 from the Laurence Miller Gallery, New York.

Robert Frank, American (born Switzerland), 1924
Car Accident—U.S. 66, Between Winslow and Flagstaff, Arizona, 1956
Vintage gelatin silver print (printed 1958–60)
11 1/8 x 17 inches (image), 13 15/16 x 17 inches (sheet)
"Robert Frank [signature] Arizona 1956," in ink, at lower right
Miscellaneous Purchase Fund, 88.74.2

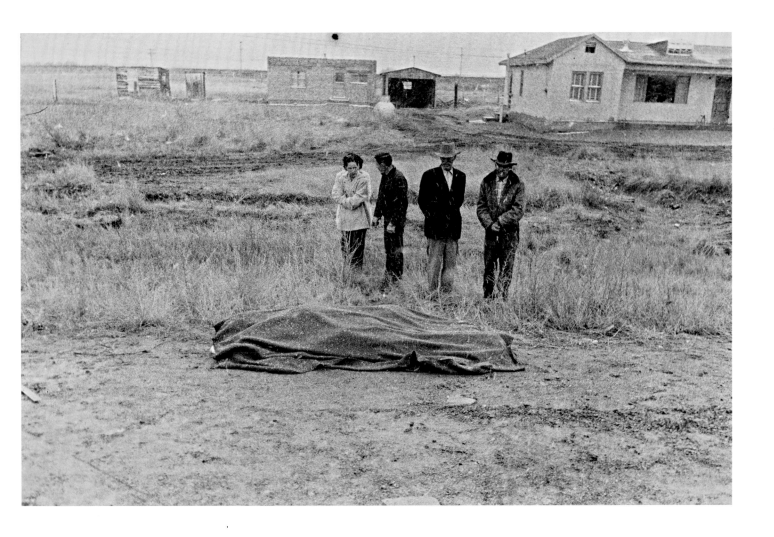

Dave Heath

IN 1962, Dave Heath organized eighty-two images, made primarily in the 1950s, into a series titled *A Dialogue with Solitude*. A dark, personal exploration of the human condition, it includes pictures of disconnected lovers, weary soldiers, disenfranchised blacks, and bewildered youths. Heath was abandoned by his parents at a young age and grew up in foster homes and orphanages; his abiding sense of rejection and isolation permeates *Dialogue*. Because most of the photographs address loneliness, detachment, seclusion, and alienation, they are overwhelmingly dark and somber. Heath began a brief commentary about the series by stating, "Disenchantment, strife and anxiety enshroud our times in stygian darkness."

The title of the collection is intentionally contradictory, since a dialogue requires two or more people, and solitude suggests isolation from others. Heath's "dialogue" was an internal conversation with his own psyche, an acknowledgment of being alone in the world. He believed that everyone, no matter how seemingly connected with others, is basically solitary.

The last group of pictures in *Dialogue* consists of images of children, a more hopeful subject. In a few cases, they are shown frowning or crying, but in others, they express joy, delight, and excitement, happily interacting with one another. Heath claimed he did not wish to convey "a sense of futility and despair, but an acceptance of life's tragic aspects," which ultimately produced "not the bitter frustration and anger of self-pity, but love and concern for the human condition."

Heath began the series with a softly focused image of Erin Freed, a little girl with large, soulful eyes, smudged cheeks, unkempt hair, and disheveled clothing. Her passive, seemingly stoic expression may have reminded the photographer of his own troubled upbringing. Erin was the daughter of Heath's friend Arthur Freed, whose image also appears in *Dialogue*. She was watching television when Heath captured her with a telephoto lens.

In 1965, the Community Press, a small outfit in Culpepper, Virginia, issued *A Dialogue with Solitude* in book form. Designed by Heath himself, it includes a moving sequence of images, sparingly interspersed with short quotations from the likes of James Baldwin and T. S. Eliot. The book received little attention when it appeared, but it has since attracted a cultlike following and recently was reprinted. Both editions feature the image of Erin Freed on the cover.

Heath's eyes were opened to the power of photography by seeing photo essays in *Life* magazine in the late 1940s. After serving in Korea during the war there, he returned to the United States to work as an assistant and freelance photographer in Chicago and New York. In the early 1960s, he received two Guggenheim Fellowships, and in 1965, taught photography as an artist-in-residence at the University of Minnesota, Minneapolis. In the late sixties, Heath began creating slide-tape shows that incorporated both his own work and that of other photographers. Heath moved to Canada in 1970, where he taught photography at Toronto's Ryerson Polytechnical Institute until 1996.

In 1990, the Minneapolis Institute of Arts purchased eighty-one prints from *A Dialogue with Solitude* from the Collected Image, a Chicago dealer that was then representing Heath. Nearly ten years later, the museum located a print of *Vengeful Sister* to complete its set. This image, perhaps Heath's most well known, depicts two screaming children after a fight. Heath printed only five or six sets of *A Dialogue with Solitude* in 1962, on single-weight, Kodak Azo paper. The only other known complete sets are at the National Gallery of Canada, in Ottawa, and the Nelson-Atkins Museum of Art, in Kansas City, Missouri. The MIA also owns a copy of *Work in Progress*, a small-edition portfolio Heath produced while teaching in Minneapolis; its five prints are similar in feeling to those in *Dialogue*.

Dave Heath, Canadian (born United States), 1931
A Dialogue with Solitude, 1962
Series of 82 gelatin silver prints, various sizes and mounts
John R. Van Derlip Fund and gift of funds from Jud and Lisa Dayton, 90.49.1-81
Alfred and Ingrid Lenz Harrison Fund, 99.73

Erin Freed

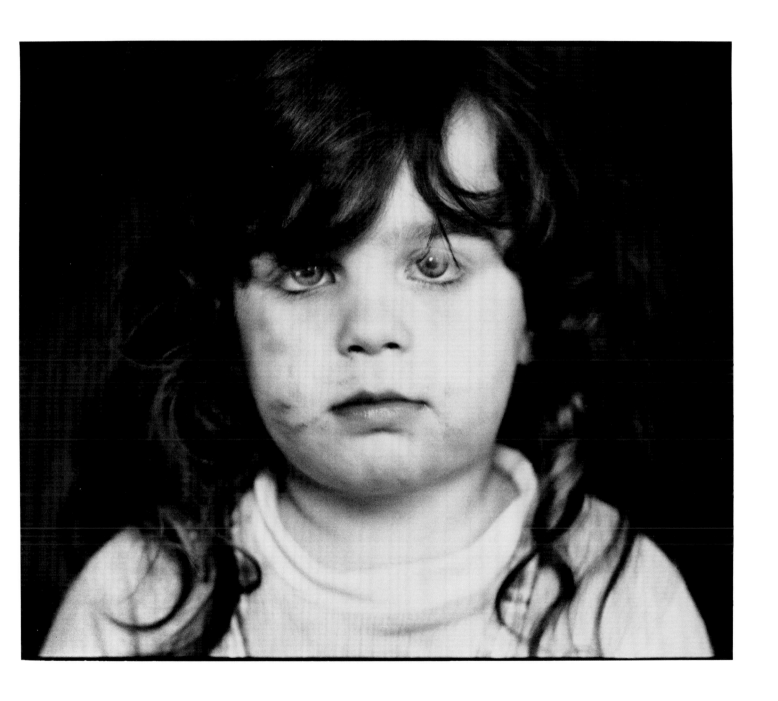

Philip Jones Griffiths

THIS IMAGE shows a female civilian who was wounded on October 17, 1967, during the Vietnam War. According to the medical identification tag perfunctorily wired to her wrist, the tragically disfigured victim suffered extensive injuries to both her left forehead and left eye. Her bandages and raised, blood-soaked hand speak poignantly to the carnage inflicted on the innocent during wartime. The standard-issue tag and the woman's covered face also suggest the anonymity of war victims, most of whom are reduced to mere numbers. This nameless individual was one of more than a million South Vietnamese civilians wounded during the conflict in Southeast Asia; approximately 250,000 died.

In the early 1960s, the United States considered Vietnam a crucial test of its policy to contain communism. It began by dispatching "military advisors" to the country, but by 1963, some 200,000 ground troops were deployed there. Much to the chagrin of President Lyndon B. Johnson and his counselors, Viet Cong guerilla tactics and Vietnamese nationalism effectively countered America's armed forces and technical superiority. The military failure in Vietnam and the vehemence of anti-war protests at home ultimately forced the United States to withdraw the last of its forces in 1975.

As a Welshman, Philip Jones Griffiths was able to view quite objectively the often-disastrous results of American foreign policy in the 1960s. He made photographs in Vietnam between 1966 and 1970, amassing a significant body of work that reflected his perspective of the situation. In 1971, Collier published his book *Vietnam Inc.*, a searing examination of the effects of the conflict on both soldiers and civilians, including roundups of the enemy, drug use, prostitution, urban decadence, the destruction of villages, and the wounded and dead. Griffiths made clear in his text that he felt the United States was arrogantly attempting to impose its own values on Vietnam, pointing out that the southeast Asian country had chosen communist politicians

in its first election, in 1946. Despite knowing that his opinion was controversial, he boldly proclaimed that he saw "the whole adventure as a simple case of the American military-industrial complex practicing genocide on the Vietnamese." *Vietnam Inc.* is one of the few books published during the war that made a case against both the conflict and war in general.

Not surprisingly, Griffiths's *Wounded Female Civilian* image has a prominent place in *Vietnam, Inc.* The last section of the book is devoted to pictures of horribly injured civilians, including infants and the elderly who have lost limbs, napalm victims with melted skin, emotionally scarred "survivors," and heavily bandaged patients. This photograph of the tagged female appears second to last, as a full-page image without any text, allowing the picture to deliver the full weight of its horrifying message. When Griffiths's major monograph, *Dark Odyssey*, was published twenty-five years later, this same image was the last in the book.

Griffiths began as a photojournalist in 1961, when he joined the staff of London's *Observer*. A few years later, as a freelancer, he covered foreign countries and wars, traveling extensively in Africa and Asia. In 1980, he moved to New York to head the Magnum photo agency, which he ran for the next five years. Subsequently, *Life* and *Geo* magazines hired him to produce photo essays on topics such as Buddhism in Cambodia, drought in India, and the revitalization of Vietnam. Griffiths also has worked as a documentary filmmaker for the British Broadcasting Company and the United Nations High Commission for Refugees.

The Chicago dealer Steve Daiter gave this print to the Minneapolis Institute of Arts in 1988. He acquired it from an individual who rescued many journalistic photographs from the trash as they were being discarded by a European photo agency. The museum owns seven others by Griffiths.

Philip Jones Griffiths, Welsh, 1936–2008
Wounded Female Civilian, South Vietnam, 1967
Vintage gelatin silver print
11 1/8 x 7 1/2 inches (image), 13 7/8 x 10 11/16 inches (sheet)
Signature, in pencil, verso
Gift of Stephen Daiter, 88.92

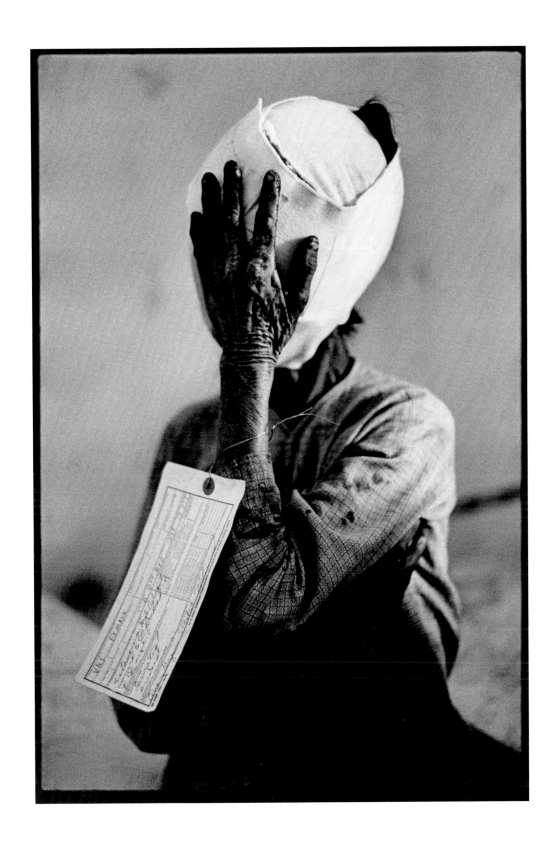

Lee Friedlander and Jim Dine

THIS IS LEE FRIEDLANDER'S first portfolio, an unusual collaboration with the painter/printmaker Jim Dine. It comprises sixteen sheets of specially made, deckle-edge paper, each of which features one or more etchings by Dine and a photograph by Friedlander. Issued in a black leatherette case, the portfolio is an unlikely confluence of media and imagery.

The two artists met in the early 1960s. Shortly thereafter, Friedlander gave Dine a photograph of Cincinnati without knowing it was the artist's hometown; this coincidence presaged the serendipitous nature of the image combinations in *Photographs and Etchings*. There is no apparent logic in most of the pairings—simply loose associations and tangential connections—with neither medium elaborating upon or interpreting the other. Dine and Friedlander reported that when they sat down to arrange their work, the photographs and etchings seemed to pair up with one another in an easy, uncalculated way. The random effect of the project is enhanced by the fact that the plates are not titled, numbered, or ordered.

Sexual imagery and autobiography abound in the portfolio. Dine rendered pubic hair and vaginal and penile imagery, while Friedlander provided photographs of the topless Baltimore stripper Blaze Starr and a man positioned to look up the skirts of two women. The two artists slyly inserted self-references into their work. Dine practiced primitive self-imaging by outlining his open palm in one print and inking the side of his hand in another. And Friedlander frequently included himself in his photographs, usually as shadows and reflections.

In the plate reproduced here, Friedlander fills his frame with foreground elements that seemingly obscure his vision and fragment the real world. This device became a hallmark of his work, where people, buildings, and signage are cut up, dissected, or otherwise visually compromised.

Unfortunately, Jim Dine denied permission to reproduce his etchings.

The same year the Petersburg Press produced *Photographs and Etchings*, another London publisher issued reproductions of its contents, in slightly altered form. The title of this book—*Work from the Same House*—aptly conveys the mutual respect the two artists felt for each other and their work. A house is a structure in which different people coexist, sharing experiences yet retaining their individuality. The portfolio and the book include a Friedlander photograph that pictures him and Dine lounging together on a bed; it suggests intimacy without physical contact. Freidlander's work is characterized by a dry, even deadpan wit. An acknowledged master of the social landscape and snapshot aesthetic, he frequently works in series form. Because of his intense involvement in their creation, most of his publications are virtual artist's books. Among the most significant are *Self Portrait* (1970) and *The American Monument* (1976).

Friedlander began working as a freelance photographer in the mid 1950s for *Esquire, McCall's, Colliers*, and other magazines. For the next twenty years, he also extensively photographed country, blues, and jazz musicians in Chicago and the Deep South. Friedlander was responsible for bringing to light the work of A.J. Bellocq, who photographed New Orleans prostitutes around 1910. On rare occasions, he also has taught—at the University of Minnesota in Minneapolis, U.C.L.A., and Rice University in Houston.

In 1976, the MIA bought fifteen plates from *Photographs and Etchings* from Gallery 12, housed in Dayton's Department Store in downtown Minneapolis. The last plate and an example of the portfolio box were acquired in 2001 from the Stephen Cohen Gallery, Los Angeles. The museum owns a total of 112 photographs and photogravures by Friedlander, most of them in portfolios and special-edition books.

Lee Friedlander, American, born 1934
Jim Dine, American, born 1935
Photographs and Etchings, 1969
Portfolio of 16 sheets with gelatin silver prints and etchings, published by
 Petersburg Press, London, in an edition of 75, 18 x 30 inch sheets
Signatures and edition number, in pencil, at bottom of sheets
National Endowment for the Arts purchase grant and gift of funds from
 Russell Cowles II, 76.16.1-15
Ethelyn Bros Photography Purchase Fund, 2001.123

Richard Avedon

THIS GROUP OF PICTURES, published in conjunction with Richard Avedon's retrospective exhibition at the Minneapolis Institute of Arts in the summer of 1970, is informally known as the *Minneapolis Portfolio*. The show, organized by Ted Hartwell, was the photographer's first major museum exhibition, signaling his entrance into the art world. The portfolio includes eleven portraits of well-known people, most of them in the arts. They are, as ordered in the portfolio's list of titles: Charles Chaplin, actor (1952), Buster Keaton, comedian (1952), Jimmy Durante, comedian (1953), Humphrey Bogart, actor (1953), the Duke and Duchess of Windsor (1957), Isak Dinesen, writer (1958), Marianne Moore, poetess (1958), Ezra Pound, poet (1958), René Clair, director (1958), Marilyn Monroe, actress (incorrectly dated as 1962), and Dwight David Eisenhower, President of the United States (1964). In addition to the list of titles, the portfolio includes a silver sheet of paper embossed with "AVEDON."

Avedon rendered most of these subjects in his classic, frontal approach, isolating them—physically and psychologically—against a white, seamless background. Chaplin and Durante clown for the camera, while the others appear composed and even self-absorbed. Life had taken its toll on many of the visages, especially the Duke and Duchess of Windsor, who appear ashen and wrinkled, and Eisenhower, who looks weary and defeated.

Of all the subjects, Monroe provided the most revealing expression and, consequently, the most memorable portrait. The star was characteristically dressed in a sequin-covered, halter-top gown that emphasized her breasts and revealed much bare skin. Avoiding eye contact with the photographer, Monroe glances down, permitting Avedon to capture her poignant vulnerability. Contributing to a sense of foreboding is the gray backdrop, with its dark tone and uneven texture. It is curious that the portfolio mistakenly dated this 1957 image as 1962, the year of Monroe's death. Perhaps Avedon sensed the inevitability of the actor's premature demise, at age thirty-six.

Avedon's intense portraits cut across social, economic, and political boundaries, and his fashion work was unparalleled. Avedon was born and lived virtually his whole life in New York City. He learned photography while in the Merchant Marines during World War II, and subsequently studied with the influential designer and art director Alexey Brodovitch. He began as a staff photographer for *Harper's Bazaar* in 1945, and shortly thereafter was photographing the Paris fashion collections. The 1957 film *Funny Face*, starring Fred Astaire, was based on his career. Avedon moved to *Vogue* in 1966, where he remained for about thirty-five years. In addition to his 1970 retrospective at the Minneapolis Institute of Arts, major exhibitions of his work appeared during his lifetime at the Metropolitan Museum of Art, the Whitney Museum of American Art, and the Museum of Modern Art. In 1992, he became the first staff photographer for *The New Yorker* magazine, where he worked until his death.

Curiously, the Minneapolis Institute of Arts did not acquire a copy of the *Minneapolis Portfolio* in 1970, when the retrospective exhibition was held here. In 1981, however, Hartwell arranged to purchase one directly from the artist, who, perceptively, had saved copy number one for the museum.

Richard Avedon, American, 1923–2004
Avedon, 1970
Portfolio of 11 gelatin silver prints
24 x 20 inches, or reverse (sheets)
Edition number (1/35) and signature, in ink, below each image
Christina N. and Swan J. Turnblad Memorial Fund, 81.94.1-11

Marilyn Monroe, Actor, New York, May 6, 1957

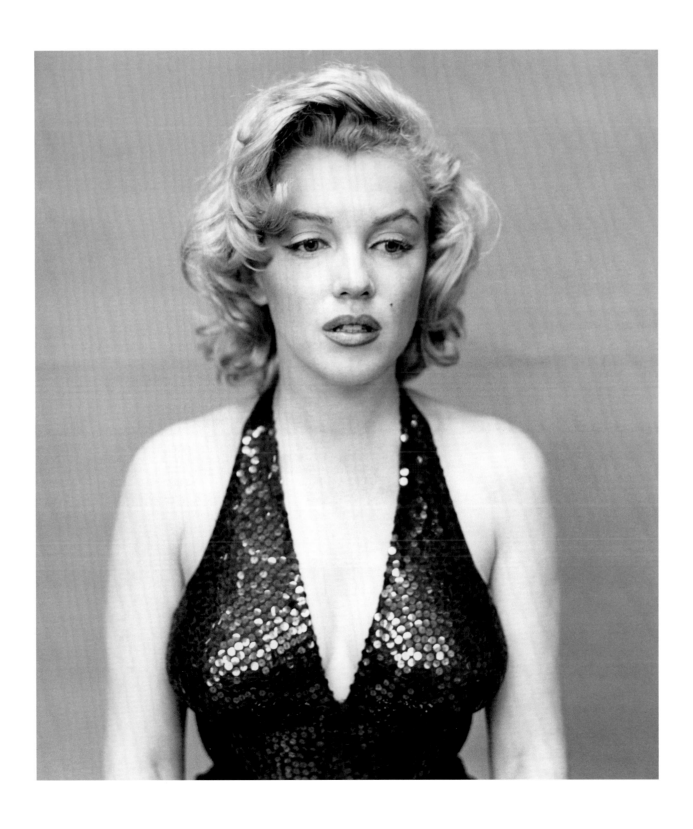

Diane Arbus

IN THE SUMMER OF 1970, Diane Arbus, a friend of Richard Avedon, came to Minneapolis for the opening of Avedon's retrospective exhibition at the Minneapolis Institute of Arts. By the end of that year, she had issued her only portfolio, *A Box of Ten Photographs*. Although "1970" appears on the portfolio's cover sheet, Arbus experienced printing and production problems and is known to have assembled only a few copies herself. In May 1971, she sent one of her handmade prospectuses about the portfolio to Ted Hartwell, whom she had met during the Avedon festivities. In June, *Artforum* ran a full-page ad for *A Box of Ten Photographs*, at no expense to Arbus because the editor had neglected to mention, as promised, the portfolio in a recent feature of her photographs and text. The next month, in July 1971, Arbus committed suicide.

Arbus reportedly sold only four copies of the portfolio, including two to Avedon and one to the artist Jasper Johns. Hartwell had began to make arrangements to acquire *A Box of Ten Photographs* upon receiving the prospectus, but Arbus's death delayed the purchase. The museum received its portfolio in September 1972, shortly after paying Doon Arbus, Diane's oldest daughter and executor of the estate, the original purchase price of $1,000. Neil Selkirk made the prints in this portfolio, which is unnumbered.

A Box of Ten Photographs was eventually completed in a numbered edition of fifty copies, with posthumous prints by Selkirk, the only person authorized to work with Arbus's negatives. It came in a specially made Plexiglas box, conceived by designer Marvin Israel to be both a container and a frame. Two holes drilled in the bottom of the box make it possible to hang the object on a wall, displaying one print in an almost invisible frame.

Arbus carefully selected the pictures in *A Box of Ten Photographs*, each of which she wished to be considered individually, a concept reinforced by the box-as-frame design. Dating from 1963 to 1970, they represent her most intensely creative period and are all essential pieces of her oeuvre.

Perhaps the most iconic is *Identical twins, Cathleen (left) and Colleen, members of a twin club in New Jersey*. One day in 1967, Arbus traveled to Roselle, New Jersey, where she photographed multiple sets of twins. These little girls stand close together on a brick sidewalk that anchors the bottom of the picture. Their stockings, dresses, hair, headbands, and even bobby pins are perfectly matched, but their faces reveal significant differences. Colleen, on the right, appears alert, happy, and childlike, while her sister looks drowsy, oppressed, and elderly. This image has been widely reproduced, most notably on the cover of the Diane Arbus monograph that Aperture published a year after her death.

Arbus photographed people primarily in and around her native New York City during the 1950s and 1960s. Conducting a kind of "contemporary anthropology," she was drawn to both conventional-seeming individuals she encountered on the street and to more eccentric types whom she sought out. She could find the extraordinary in the everyday and commonality in the unusual. Her colorful subjects included strippers, carnival performers, transvestites, nudists, midgets, dwarfs, and giants. All her mature photographs feature a formal approach to the subjects in a square picture frame.

Born Diane (pronounced Dee-Ánn) Nemerov, she married Allan Arbus in 1941, and worked for the rest of the decade in partnership with her husband as fashion photographers. In the late 1950s, she studied with Lisette Model, a photographer noted for her harshly realistic images who encouraged Arbus to continue to pursue personal work. She supported herself during the 1960s making portraits and photographic essays for magazines like *Esquire* and *Harper's Bazaar*. The Guggenheim Foundation awarded her fellowships in 1963 and 1966 for a project she called "American Rites, Manners and Customs." Later in the decade, she taught at Parsons School of Design, Rhode Island School of Design, and Cooper Union.

Diane Arbus, American, 1923–71
A Box of Ten Photographs, 1970, portfolio of 10 gelatin silver prints
20 x 16 inches (sheets)
Printed label, verso, with title, date, and printing information
 written in ink, and Doon Arbus's signature in ink
Kate and Hall J. Peterson Fund, 72.109.1-10

Identical twins, Cathleen (left) and Colleen, members
of a twin club in New Jersey, 1967

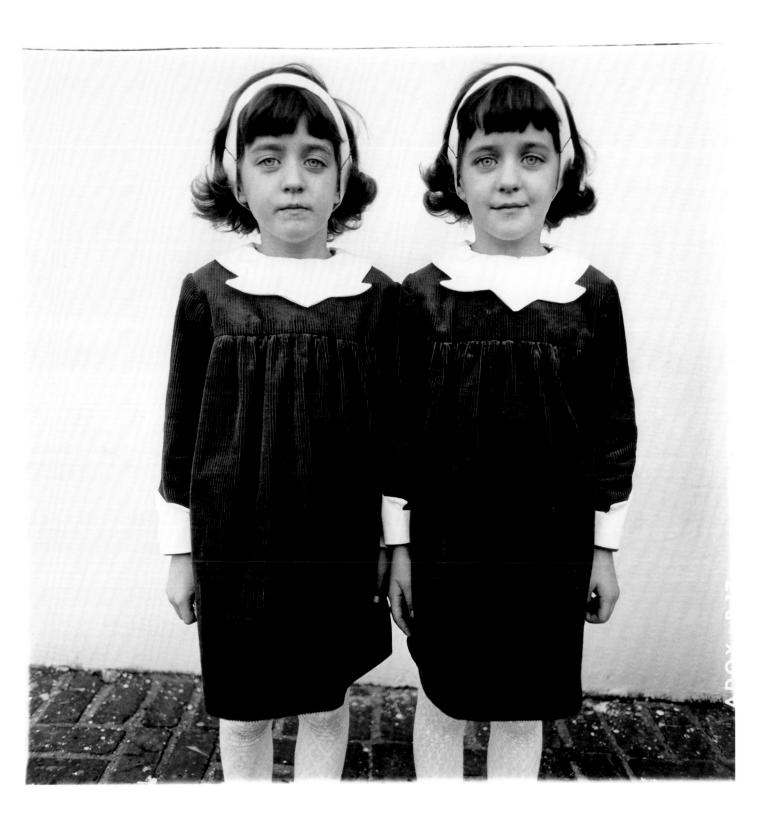

William Eggleston

WILLIAM EGGLESTON'S PICTURE of a tricycle is one of the photographer's signature images. It has gained iconic status in his oeuvre because of its banal simplicity, understated color, and appearance on the cover of his 1976 book, *William Eggleston's Guide*.

While all of Eggleston's photographs posit the significance of the everyday, this one perfectly aligns subject matter and attitude. The photographer delights in making images that appear random and offhand. In fact, most of them seem so mundane—and so like snapshots—that a child might have taken them. In this case, Eggleston chose an object closely associated with childhood, an unadorned trike, which he photographed by placing his camera nearly on the ground. This viewpoint renders the tricycle large in the picture frame, seeming to loom over suburban houses and a parked car. Tellingly, the sky is a cold gray and the strip of boulevard grass brown and lifeless. The tricycle itself is worn and rusted, void of a brand name or any other distinguishing marks. Perhaps, for Eggleston, it symbolized the desolation and malaise that characterize this bleak scene.

Eggleston has long been associated with Memphis, Tennessee, where he was born and has lived all his adult life. He has photographed the South almost exclusively, capturing the region's vernacular architecture and distinctive signage, vegetation, and inhabitants. Eggleston began shooting color in 1965, and is generally credited with making it acceptable in the world of creative photography. In 1976, New York's Museum of Modern Art presented a one-person exhibition of his color work, creating controversy about both the medium and the photographer's understated approach. His *Guide*, designed rather like a children's book, accompanied the show, and prompted many observers to wonder who was guiding whom. Eggleston was commissioned to photograph Plains, Georgia, before the presidential election of its favorite son, Jimmy Carter, and Graceland, Elvis Presley's Memphis home. With a strong interest in sound and technology, he also has dabbled in filmmaking.

The museum bought this print of *Memphis* in 1979 from Caldecott Chubb, who was then Eggleston's representative and publisher. The MIA owns eight photographs by Eggleston, including a dye-transfer print of his red ceiling, which is equally seminal.

William Eggleston, American, born 1939
Memphis, c. 1970, dye transfer print (printed 1976)
12 1/16 x 17 3/16 inches (image), 15 7/8 x 20 1/16 inches (sheet)
Signed, in pencil, verso
Kate and Hall J. Peterson Fund, 79.34.1

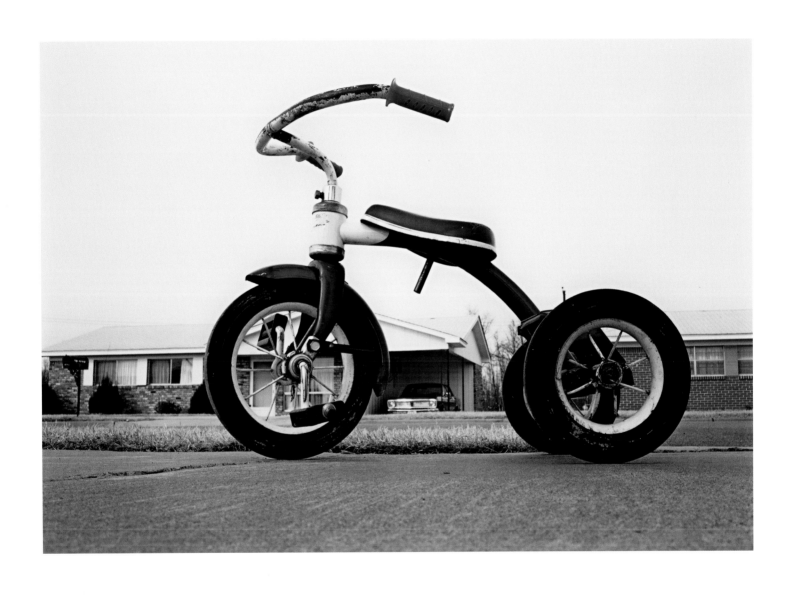

Frank W. Gohlke

ACCORDING TO FRANK GOHLKE, "The grain elevator is the essential American monument. No other structure so completely testifies to the vastness of the American landscape and the magnitude of its production." Called elevators because of their internal conveyor belts that distribute grain by hoisting it upwards, they temporarily hold cash crops between harvest and shipment to market. Corn, wheat, barley, rice, and soybeans fill these often cylindrical shells. Usually located in small towns on the Midwestern prairie, they can be seen from miles away, looming large over their surroundings.

From 1972 to 1977, Gohlke concentrated on photographing these structures, creating what is perhaps his most defining body of work. He initially engaged his subject at close range, making primarily formalistic images of line, shape, shadow, and light. Eventually stepping back from and even climbing on top of the elevators, he began to show them integrated into vast landscapes or tiny outposts of civilization. While evidence of mankind is always visible, human beings never appear in his images. Sometimes, he rendered the elevators as mere sticks on the distant horizon, drawing close associations with the steeples of rural churches.

Grain Elevators and Lightning, Lamesa, Texas, has become Gohlke's most recognizable elevator picture. This photograph is one of the few not taken in broad daylight and under ideal weather conditions. Instead, Gohlke made it immediately after a violent storm had passed through the small western Texas town; the wet, glistening roadway fills the entire bottom half of the image and beautifully reflects the Kimbell Milling Company's set of elevators. Most noteworthy and serendipitous is the bolt of lightning, which, appropriately enough, provides a highly charged backdrop to the silhouetted power lines along the side of the road.

Bits of signage punctuate the image, providing both factual information and allusions to death. Most prominent is the milling company's name, which lives on today as the Kimbell Art Museum in nearby Fort Worth. The name of another business, Fina, appears on the black truck at the left edge of the image. Does it refer to the end of the storm, or perhaps to the eventual decline of small-town agriculture and the need for the type of mid-size elevators pictured here? Finally, there is the name of the high-school sports teams—the Tornadoes—on the water tower in the distance; surely this served as a constant reminder to Lamesa residents of the destructive twisters that rip through the area.

Gohlke was pursuing a Ph.D. in English at Yale University when he met Walker Evans, who was then teaching photography there. Gohlke did not take classes with Evans, but was encouraged by him to continue photographing. His earliest mature work and all his grain elevator pictures were made while he lived in Minneapolis, from 1971 to 1987. He traveled regularly throughout the Midwest, making photographs of rural, suburban, and urban vistas. Not interested in the pristine, glorified landscapes of the likes of Ansel Adams, he instead pictured man's imprint on the earth, becoming part of the mid-1970s "New Topographics" movement. After completing his elevator series, Gohlke photographed the ravages of natural disasters, such as a tornado in his hometown of Wichita Falls, Texas, and the eruption of Mount St. Helens in Washington State. He has made many aerial images of the American landscape and color photographs both in this country and Europe. His work is unfailingly precise and economical, and reflects, in his words, a "neutrality of description." Gohlke has taught photography at many eastern colleges, and since 2007, has been a professor at the University of Arizona, in Tucson.

Martin G. Weinstein obtained this photograph from the photographer and, in 1984, gave it to the Minneapolis Institute of Arts, which owns seventy-one prints by Gohlke.

Frank W. Gohlke, American, born 1942
Grain Elevators and Lightning, Lamesa, Texas, 1975
Gelatin silver print (printed 1981)
14 x 14 1/16 inches (image), 19 7/8 x 16 inches (sheet)
Verso, in pencil: signature, title, date, print date, and negative number
Gift of Lora and Martin G. Weinstein, 84.125.12

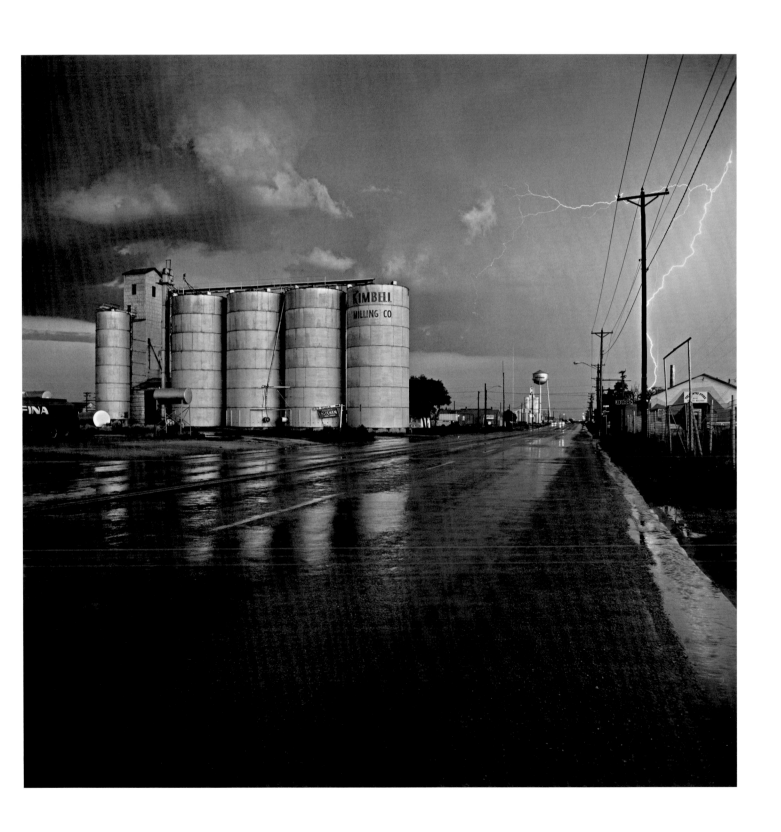

Joel Meyerowitz

THIS IS ONE of many photographs Joel Meyerowitz made at the seaside house in Provincetown, Massachusetts, that he rented with his family in the summer of 1977. Located at the extreme tip of Cape Cod, Provincetown is nearly surrounded by the waters of the Atlantic Ocean and Cape Cod Bay, and is known for its views, beaches, and quaint architecture. At different times of day and under various lighting conditions, Meyerowitz photographed the dwelling's expansive porch and the water and sky beyond it. He considered light, in fact, to be his primary subject, and published the fruits of this and a previous summer's work in the locale as the book *Cape Light* (1978).

The pastel palette and simple geometry of this picture make it the most sensuous and pleasing of the photographer's porch images. Obviously, Meyerowitz was working at sunset, the time of day when objects are bathed in a rainbow of seductive orange, yellow, and red hues. Perfectly complementing these colors are the blues and purples in the water and sky, producing a visual confection that borders on the saccharine.

Meyerowitz relied on the architectural elements of the porch—the roofline, vertical columns, and railing—to create a rigid pictoral structure. All are composed of unyielding, straight lines that both frame the foreground and break up the background. It is no accident that the edge of the roof hits one corner, that the main column is perfectly centered, and that the diagonal lines of the railing and roof would, if extended, meet on the horizon.

Despite its apparent sense of pristine perfection, the image contains several subtle intrusions. Most noticeable is a boat, truncated by the rear column. Also visually invasive are two unidentified objects—one in the water (seen between the two columns) and another at the bottom right corner. Close inspection of the columns reveals nicks in the wood and missing paint.

Meyerowitz left his job as an art director in 1963 to devote himself to photography. For several years, he was an accomplished street photographer, quickly catching black-and-white images with the requisite small-format camera. By 1970, however, he was making color photographs with a large-format camera, and during the next decade, he received two Guggenheim Fellowships and a commission to photograph the St. Louis Arch. In 1994, he coauthored the book *Bystander: A History of Street Photography*.

Meyerowitz has long been a committed colorist and devotee of the beautiful, often issuing his photographs as striking eight-by-ten-inch contact prints. Following the terrorist attacks on New York's World Trade Center in 2001, he secured coveted long-term access to Ground Zero, and subsequently produced an extensive body of work that found grace and elegance at the site of turmoil and devastation.

Porch, Provincetown, Cape Cod was purchased from the Witkin Gallery, New York, in 1978, a year after the artist made it. The museum owns eight photographs by Meyerowitz.

Joel Meyerowitz, American, born 1938
Porch, Provincetown, Cape Cod, 1977, color coupler print
9 5/8 x 7 5/8 inches (image), 13 15/16 x 11 inches (sheet)
Verso, in ink: partial title, date, signature, and photographer's reference numbers
Mr. and Mrs. Harrison R. Johnston, Jr., Fund, 78.15

Robert Adams

TO MAKE THIS IMAGE, Robert Adams set up his large-format camera on the banks of the Missouri River in southeastern South Dakota, looking across to neighboring Nebraska. Even though the Missouri is a tributary of the Mississippi, its length equals that of the mightier river. It begins in southwestern Montana and flows east and south to just north of St. Louis. Judging by the frozen area midstream, Adams photographed this locale either late in the fall or early in the spring.

Like his contemporary Frank Gohlke, Adams eschewed the classic landscape beauty of his namesake (and no relation) Ansel Adams. Instead, he found the transcendent and sublime in subjects that were mundane and even banal. This scene, for instance, is of an unpicturesque stretch of the Missouri, where bare trees, common rocks, and rough ground comprise a seemingly unremarkable vista. Yet Adams observes the place with such seriousness and intensity that the photograph becomes an homage to visual perception and an example of simple nature worship. The photographer, deeply concerned about the impact of humankind on the land, discreetly included a discarded beer can in one corner of the image to illustrate how man-made litter defiles the natural world.

This image is one of a series of landscape photographs of the American West that Adams made in the late 1970s.

Aware that in the nineteenth century the American frontier began at the Missouri River, he photographed from there to the Pacific Coast, creating one of his most respected bodies of work. The understated images generally show where the terrain has just begun to be altered by such human activities as littering, logging, and construction. The project culminated in the book *From the Missouri West* (1980), which included this image.

Adams taught English for about a decade before turning to photography in 1970. Based in Denver, he initially photographed suburban tract houses encroaching on the surrounding land. Subsequent projects took him farther into the American wilderness but not beyond the point where humans had left their mark. During the 1970s, as a part of the "New Topographics" movement, he received grants and fellowships from both the National Endowment for the Arts and the Guggenheim Foundation. Adams is as eloquent a writer as photographer, having authored books such as *Beauty in Photography: Essays in the Defense of Traditional Values* (1981).

The photograph *Missouri River, Clay County, South Dakota* is one of four by Adams owned by the Minneapolis Institute of Arts. It was bought by First Banks from the Daniel Wolf Gallery, New York, in 1981, and given to the museum in 1987.

Robert Adams, American, born 1937
Missouri River, Clay County, South Dakota, 1977, gelatin silver print
8 15/16 x 11 3/16 inches (image), 10 7/8 x 13 7/8 inches (sheet)
Verso: signature and title, in pencil, and "Copyright © Robert Adams," wet stamp
Gift of First Banks, 87.35.1

Joel-Peter Witkin

WOMAN BREASTFEEDING AN EEL is a disturbing image that typifies Joel-Peter Witkin's work. While the title suggests that the large-breasted female is voluntarily performing a nurturing act, the photograph suggests otherwise. Since her hands are not visible, it is possible that the snakelike fish has attached itself to her nipple, acting as a predator. Forced attack or even bondage is implied by the mask and neckband the woman wears. Furthermore, the mask grants her anonymity and seems to diminish her responsibility for the disturbing activity.

This high-contrast image is largely composed of dark shadow areas and white highlights. The eel's slithering underbody and the woman's exposed skin shimmer brightly, as if lit from above. The blacks of the image are deep and unforgiving, swallowing up most of the figure and background. Only the mask and portions of the backdrop yield texture, seemingly rough and random. The mask, a hand-crafted beak, bears abstract-expressionistic scrawls, and the space above the figure's head shows aggressive marks made on both the backdrop and the negative. Witkin claims he was interested in evoking the atmosphere of photo booths that offer a strip of crude wallet-size "self-portraits." This large-scale picture, however, looks more like the scene of a crime or a party gone horribly wrong.

Welcome to the Bosch-like world of Witkin, who has fabricated images dealing with pain, violence, and death for thirty years. His work invariably involves elements of the grotesque, morbid, perverse, obscene, incendiary, demonic, hedonic, and forbidden. He regularly explores sexual obsessions, fixations, aberrations, and fetishes. Aiding him is an assortment of unusual and willing subjects, who frequently have missing, additional, or enlarged limbs and sexual organs. Dismembered body parts, corpses, and animals also inhabit his photographs. Perhaps not surprisingly, Witkin's earliest childhood recollection is that of a young girl's severed head rolling toward his feet at the scene of a car crash. Shortly thereafter, he became fascinated with the sideshow freaks at Coney Island, which he visited with his twin brother, who now paints canvases almost as unsettling as Joel-Peter's photographs.

Witkin, despite the appearance of his imagery, is not interested in pornography or even titillation. Instead, he considers his work "prayers," and makes portraits not of individuals but of the human "condition of being." A meticulous planner, he often makes preparatory drawings, and always works in the studio, where he has complete control over his subjects, props, and lighting. His photographs are often based on specific historical paintings by such masters as Rembrandt, Goya, and Courbet. His prints usually appear aged and even deteriorated, the results of the photographer's expressive handwork and selective toning.

During the late 1950s, Witkin worked in various New York photography studios and labs, and he studied sculpture at Cooper Union, where he made figure pieces that presage the look of many of his later photographs. He was an Army photographer during the early 1960s, capturing, among other subjects, military suicides and victims of accidental deaths. In 1975, he moved to New Mexico to attend graduate school in photography in Albuquerque, where he has lived ever since. He has received three grants from the National Endowment for the Arts.

This print was purchased in 1986 from Witkin's dealer, the Fraenkel Gallery in San Francisco. It is the only one by the photographer in the museum's permanent collection.

Joel-Peter Witkin, American, born 1939
Woman Breastfeeding an Eel, New Mexico, 1979, gelatin silver print
28 1/4 x 28 inches (image), 35 3/16 x 30 1/8 inches (sheet)
Signature, title, date, and edition number (3/3), in pencil, verso
Mr. and Mrs. Patrick R. Butler Fund and Fiduciary Fund, 86.2

Gilles Peress

BETWEEN 1977 AND 1979, Iran experienced its Islamic Revolution, a turbulent reaction to the liberalization foisted upon the country by the American-backed shah. In 1979, Shah Mohammad Reza Pahlavi fled Iran, and the mullah Ayatollah Khomeini returned from exile. On November 4, militant students seized the American embassy, taking seventy-two hostages and demonstrating to the United States the power of Islamic fundamentalism. The American media responded with extensive print and broadcast coverage of a country and culture it little understood; one product of this burgeoning awareness was the news show *Nightline,* which originally was devoted exclusively to the hostage crisis.

The French photojournalist Gilles Peress was so surprised by the extent of this coverage and so intrigued by what actually might be happening in Iran that he traveled there in December 1979. For five weeks, he photographed a nation in turmoil, as it wrestled with both an internal power struggle and the heightened attention of much of the external world. Countering the routine photojournalistic conceit of presenting an objective and comprehensive view of his subject, Peress pursued a highly personal approach in Iran. He immersed himself in crowds, markets, demonstrations, and religious gatherings in order to experience the situations on an individual and human level. Many of the resulting images are fragmented and disorienting, reflecting the upheaval he witnessed. Peress often created pictures with unusual juxtapositions and deep shadows rather than straightforward images that were easily deciphered.

This photograph shows a political demonstration for Shariatmadari, an Islamic mullah who briefly competed with Khomeini for the role of supreme leader. Peress took the picture in Tabriz, a city in the northwestern corner of Iran, near the border with Turkey and what was then the Soviet Union. Dominating the foreground are a placard for Shariatmadari and the heads of two young supporters, all of which are severely cropped by the picture frame. The men milling around and standing on top of structures attest to the disarray of the event. By tilting his camera and using a wide-angle lens, Peress created a distorted image that looks like two pictures in one. Because it is bisected in the center, the photograph was ideal for the cover of his book *Telex: Iran: In the Name of Revolution* (1983), with one half on the front and the other on the back.

Peress began photographing in 1970 and soon committed himself to exploring the social, political, and cultural makeup of the world; within two years, he was a member of Magnum, the world's leading agency of photojournalists. He moved from Paris to New York in 1975, and soon was receiving grants and fellowships from organizations such as the National Endowment for the Arts and the Guggenheim Foundation. In 1984, he was honored with the W. Eugene Smith Award for Humanistic Photography. Shortly thereafter, Minnesota's First Banks commissioned him to photograph the Twin Cities of Minneapolis and St. Paul. Most of his projects have focused on war-torn parts of the world and have resulted in such books as *Farewell to Bosnia* (1994), *The Silence: Rwanda* (1995), and *The Graves: Srebrenica and Vukovar* (1998).

The Minneapolis Institute of Arts acquired this set of sixty-three images from *Telex: Iran* directly from the photographer in 1986. In appreciation of this commitment to his work, Peress gave the museum miscellaneous working materials for the book and three maquettes, one of which is a slightly oversize version with original photographs. The MIA owns more than 500 photographs by Peress, including large groups from his work in Northern Ireland, Bosnia, and Rwanda.

Pro-Shariatmadari Demonstration, Tabriz, Iran

Luis González Palma

AMERIKA is one of Luis González Palma's early, emblematic pieces. It showcases his engagement with the indigenous culture of his native Guatemala, his adept manipulation of the photographic image, and the impact of his large-scale prints. Made only six years after he took up photography, it helped propel him to international renown in the early 1990s.

The young Guatemalan woman pictured in *Amerika* formally and stoically faces the camera, her passive expression giving no hint of her thoughts or emotions. The photographer was drawn to his country's ancient culture, and in this somber image evokes the solitude, pain, and racial discrimination of Guatemala's native people. The subject wears the Virgin's crown, a symbol of holy worship that also suggests a cheap souvenir made of tin. Contrasting strongly with this celestial crown is the dark, dripping pigment at the bottom of the picture, boldly referencing blood and the crucifixion. These markings also may be interpreted as tears, given the woman's unsettling stare. Except for the whites of her eyes, the image is toned in shades of brown, a color reminiscent of both the earth and Indian skin.

Adopting the ancient Mayan belief in an otherworldly and magical universe, González Palma consistently makes images that are spiritual, theatrical, and metaphorical. Almost invariably, he photographs solitary figures, creating portraits that seem to transcend the individual and capture the essence of a race and its culture. Influenced by the statues, paintings, and altarpieces of Guatemala's baroque churches, he frequently adorns his subjects with wings, roses, crowns, and other iconic items. In a nod to native handcrafts, González Palma cuts, tears, scratches, and collages his photographs. He also often prints them large— this one measures more than five feet high—in order to add a sense of immediacy and confrontation.

The title of the photograph alludes to the subversive way participants in the 1960s counterculture in the United States spelled the name of this country. It is also intended to remind viewers that the term American applies equally to all the inhabitants of North, Central, and South America.

González Palma studied architecture and cinematography at the Universidad de San Carlos de Guatemala. While working as an architect, he took up photography in the mid 1980s, and was exhibiting photographs and installations by the end of the decade. He has presented one-person exhibitions of his work in Guatemala, Mexico, Spain, France, Scotland, and the United States; since 2000, he has shown twice in the Venice Biennale. He now lives in Argentina.

The museum purchased *Amerika* in 1992 from Chicago's Stephen Daiter, one of the photographer's early dealers. González Palma is represented by eight photographs in the permanent collection.

Luis González Palma, Guatemalan, born 1957
Amerika, 1990, gelatin silver print, hand-painted
60 1/2 x 19 7/8 inches (image and sheet)
Signature, verso
Gift of funds from Lisa Dayton, 92.120.1

Alec Soth

THIS GROUP OF PHOTOGRAPHS comprises a complete set of the images in Alec Soth's 2004 book *Sleeping by the Mississippi*, plus six additional prints selected by the photographer. It is the only full set of these pictures and represents the largest of three sizes in which Soth prints.

Charles, Vasa, Minnesota, the signature picture of both the series and the photographer, is widely reproduced and coveted by collectors. Soth found the subject for this photograph, like all the others in the book, while meandering along the Mississippi River on one of several road trips between 1999 and 2002. Outside Vasa, Minnesota, a small town fifteen miles west of Red Wing, he spotted a house with a curious glass room on its roof. It had been built by Charles, an affable eccentric who also had moved the staircase in his house three times. Soth appreciated the subject's lofty aspirations, as well as his hands-on approach to life. In the picture, he played up the allusions to air travel, as the aviator Charles Lindbergh was a touchstone for the Mississippi River project; Charles wears work clothes that resemble a flight suit and shows off his model airplanes, one of which looks like patriotic folk art.

Soth used a large-format camera for his Mississippi pictures because setting up such equipment is a time-consuming process that assures the subject is complicit in the undertaking. Furthermore, this type of camera usually yields photographs that appear tranquil and deliberate. Soth's eight-by-ten-inch negatives provide impeccable detail when enlarged, thus enhancing the seemingly documentary nature of his work.

The photographs in *Sleeping by the Mississippi* are, however, personal statements rather than objective records. They represent Soth's intention to go with the flow of the river and observe the humanity along its banks. Influenced by William Eggleston and Joel Sternfeld, Soth engaged the banal as well as the lyrical in his images of individuals, landscapes, and domestic interiors. Although he photographed along the entire 2,300-mile length of the Mississippi and the book's images proceed southward from Minnesota to Louisiana, the series is neither a narrative nor a travelogue. The word *sleeping* refers to an unconscious state of mind that often involves dreaming—a liberating, invigorating, and uncensored mental activity. Not surprisingly, beds appear with some frequency in the pictures, as do occasional sexual suggestions. Soth's photographic journey along the river was simultaneously serendipitous and ordered, lonely and engaging, introspective and revealing.

Soth, a Minneapolis native, has always lived in his hometown, except while attending college on the East Coast. He worked from 1996 to 2003 at the Minneapolis Institute of Arts as a darkroom technician and digital-image specialist. He burst onto the international art scene in 2004, when he exhibited in both the Whitney and São Paulo Biennials and when the German publisher Steidl issued *Sleeping by the Mississippi*; *Charles* appears on the cover of the second of two sold-out editions. His subsequent books are *Niagara* and *Dog Days, Bogotá*. Soth is a member of Magnum, the world's premier organization of photojournalists, and has worked on assignment for magazines such as *The New Yorker* in China, Brazil, and Europe.

This set of *Sleeping by the Mississippi* was acquired through purchase from Solomon Fine Art, Monarch Beach, California, and generous gifts from the artist and other donors. It joins seven other photographs by Soth in the museum's collection.

Alec Soth, American, born 1969
Sleeping by the Mississippi, 2000–2002, series of 52 color coupler prints
50 x 40 inches, or reverse (image, sheet, and mount)
Alfred and Ingrid Lenz Harrison Fund, 2007.109.1-18
Gift of the artist and Dan and Mary Solomon, 2007.110.1-18
Gift of Nancy and Mitchell Stein, 2007.111.1-8
Gift of Emily and Mark Goldstein, 2007.112.1-8

Charles, Vasa, Minnesota, 2002

Exhibitions Organized by Carroll T. Hartwell

"A Century of American Photography"
November 27, 1963–January 19, 1964

"The Aesthetics of Photography:
The Direct Approach"
May 20–July 14, 1964

"Myron Papiz"
October 13–November 24, 1965

"Tom Muir Wilson"
December 7, 1965–January 23, 1966

"Ilyana Garmisa: Travel Photographs"
March 29–May 8, 1966

"Photography from the Metropolitan
Museum of Art"
December 17, 1966–January 31, 1967

"Ron Dow"
May 10–June 11, 1967

"Danny Seymour"
October 4–30, 1967

"Thomas Bouchard"
November 9–December 3, 1967

"Young Chicago Photographers"
December 7, 1967–January 14, 1968

"Photographs from the
Siembab Gallery"
January 15–February 16, 1969

"Photographs by Elaine Mayes:
We Are the Haight-Ashbury"
March 28–May 4, 1969

"Photographs from the Permanent
Collection"
August 16–September 29, 1969

"Mario Jorrin"
December 1, 1969–January 1, 1970

"Avedon"
July 2–August 30, 1970

"Ramon Muxter: Photographs"
September 11–October 12, 1970

"Stephanie Torbert: Photographs"
October 16–November 16, 1970

"High School: Richard Olsenius"
March 2–April 4, 1971

"Murray Riss: Photographs"
April 10–May 9, 1971

"Recent Accessions"
June 4–July 13, 1971

"Keith Laumb: Photographs"
October 16–November 21, 1971

"Images from Another Place:
Photographic Series by Chris Cardozo"
November 27–December 26, 1971

"Gary Hallman: Photographs"
December 31, 1971–January 30, 1972

"Stuart Klipper: Photographs"
February 4–March 5, 1972

"Photographs from the Permanent
Collection"
March 11–April 16, 1972

"Diane Arbus: A Box of Ten Photographs"
(exhibited at the Martin Gallery)
January 13–February 7, 1973

"Robert Wilcox"
January 10–March 2, 1975

"Minnesota Photographers"
July 9–September 7, 1975

"Selections from the Permanent
Collection"
September 17, 1975–June 27, 1976

"Glen Halvorson/Roger L. Kreidberg/
John Vong"
December 3, 1975–January 11, 1976

"Harry Callahan and Wright Morris"
March 17–April 4, 1976

"The Kate and Hall J. Peterson Fund:
Purchases for the Permanent Collection"
May 12–June 27, 1976

"Edward Curtis:
Native American Images"
July 4–August 8, 1976

"Lee Friedlander: Four Portfolios"
September 15–October 31, 1976

"Recent Accessions:
NEA Photography Purchase Grant"
November 3–December 26, 1976

"Linda Rossi: Seven Days"
January 6–February 6, 1977

"Photographs by Walker Evans
from the Arnold H. Crane Collection"
April 6–May 8, 1977

"Christopher James:
Hand-Colored Photographs"
July 13–August 28, 1977

"B. A. King: Photographs"
September 7–October 30, 1977

"Minnesota Survey:
Six Photographers"
January 14–February 26, 1978

"Photography: Permanent Collection"
March 11–October 13, 1978

"Allen Swerdlowe:
Van Dyke Brown Prints"
March 20–May 13, 1979

"Selections from the Permanent
Collection"
May 20–June 24, 1979

"Michael Simon"
May 20–June 24, 1979

"James Henkel: Recent Color"
October 9–November 18, 1979

"Carl Chiarenza: Photographs"
November 25, 1979–January 4, 1980

"Eve Sonneman: Work from 1968–1978"
January 11–March 9, 1980

"Contemporary California
Photographers"
March 21–May 4, 1980

"The Permanent Collection:
Photographs Acquired 1969–80, Part I"
March 21–June 21, 1981

"The Permanent Collection:
Photographs Acquired 1969–80, Part II"
July 8–December 10, 1981

"Sandy Skoglund"
December 19, 1981–February 7, 1982

"The Permanent Collection:
A Selection of American Images"
February 20–March 21, 1982

"The Permanent Collection:
Photographs Acquired 1981"
March 27–May 9, 1982

"Tom Arndt's America"
November 21, 1984–January 6, 1985

"Photographs from the Permanent
Collection, Part I"
March 9–May 26, 1985

"Photographs from the Permanent
Collection, Part II"
June 1–August 18, 1985

"The Art of Collecting: Photography"
January 18–June 1, 1986

"About Faces: Portraits
from the Permanent Collection"
August 23–October 26, 1986

"Lee Friedlander at Cray Research"
November 27, 1987–February 7, 1988

"Ansel Adams and Berenice Abbott:
Photographs"
November 12, 1988–February 19, 1989

"Portraits: A Selection
from the Permanent Collection"
July 22–August 20, 1989

"Recent Accessions
in Photography, 1984–1990"
May 20–September 23, 1990

"Sylvia Plachy's Unguided Tour"
October 20, 1990–January 13, 1991

"Telex: Iran: In the Name of Revolution"
June 8–July 25, 1991

"The Permanent Collection:
A Brief History of Photography"
November 30, 1991–March 1, 1992

"Martin Weinstein's Gifts to the
Photography Collection"
March 14–July 12, 1992

"Stuart Klipper: Photographs from
Polar Regions"
August 1–November 15, 1992

"Gus Foster–Panoramic Photographs"
March 13–June 27, 1993

"Three Portfolios: Diane Arbus,
Richard Avedon, and Neil Selkirk"
July 24–October 3, 1993

"David Heath: A Dialogue with Solitude"
February 19–May 31, 1994

"The People, Yes: The Photographs of
Jerome Liebling"
March 4–June 11, 1995

"The Search to See: The Collection and
Photographs of Frederick B. Scheel"
June 24–December 3, 1995

"Henri Cartier-Bresson:
Pen, Brush, and Cameras"
March 3–May 12, 1996

"Photography:
The Collection Grows, 1983–1996"
May 31–August 24, 1997

"New York, New York: Images of the City"
June 13–August 23, 1998

"Help Wanted: Child Labor Photographs
by Lewis W. Hine and David L. Parker"
May 22–September 26, 1999

"Arnold Newman Portraits"
March 4–July 23, 2000

"Berenice Abbott: American Photographer"
February 3–June 17, 2001

"Danny Lyon: Photographs, 1962–2000"
December 1, 2001–April 7, 2002

"Times Squared:
Photographs by Toby Old"
May 4–July 14, 2002

"Ruth Bernhard: Photographs 1930s–1970s"
August 10–October 20, 2002

"Werner Bischof Photographs: 1932–1954"
October 4, 2003–February 15, 2004

"Selections from the Permanent
Collection"
July 31–December 5, 2004

"Marc Riboud:
Photographing the World, 1953–2005"
March 11–May 14, 2006

"Highlights from the Harrison Collection
of Fine Photographs, 1992–2006"
June 11–October 8, 2006

"The Search to See: Photographs from the
Collection of Frederick B. Scheel, Part I"
July 7–November 4, 2007

Publications by Carroll T. Hartwell

The Aesthetics of Photography: The Direct Approach. Minneapolis: Minneapolis Institute of Arts, 1964.

"An Edward Weston Portfolio." *The Minneapolis Institute of Arts Bulletin* 58 (1968): 58–59.

"Books: A Photographer's Library." *Twin Cities Express* 1 (July 31, 1974): 15.

"The Robert Wilcox Collection." *The Minneapolis Institute of Arts Bulletin* 61 (1974): 104–7.

"Photography: Practice/Presumptions." In *Press Photography: Minnesota Since 1930,* 14–19. Minneapolis: Walker Art Center, 1977.

Minnesota Survey: Six Photographers. Minneapolis: Minneapolis Institute of Arts, 1978.

The Making of a Collection: Photographs from the Minneapolis Institute of Arts. New York: Aperture, 1984.

Martin Weinstein's Gift to the Photography Collection. Minneapolis: Minneapolis Institute of Arts, 1992.

Gus Foster—Panoramic Photographs. Minneapolis: Minneapolis Institute of Arts, 1993.

"Two American Photographs: Similarly Subjective but Definitely Different." *Arts* 17 (August 1994): 5.

"The Search to See: The Collection and Photographs of Frederick B. Scheel." *Arts* 18 (July 1995): 5.

Foreword. In *Jerome Liebling, The People, Yes,* 4–5. New York: Aperture, 1995.

"The Artist as Photographer." In *Henri Cartier-Bresson: Pen, Brush, and Cameras,* unpg. Minneapolis: Minneapolis Institute of Arts, 1996.

"Help Wanted: Photographs by Lewis W. Hine and David L. Parker." *Arts* 22 (May 1999): 4–5.

"Portraits of the Artists: Arnold Newman." *Arts* 23 (March 2000): 6–8.

"Historian of Human Life: Berenice Abbott." *Arts* 24 (January/February 2001): 6–7.

"Times Squared: Toby Old." *Arts* 25 (May 2002): 18–19.

"Ruth Bernhard: Photographs 1930s–1970s." *Arts* 25 (September 2002): 20–21.

"The Face of Human Suffering: Werner Bischof Photographs, 1932–1954." *Arts* 26 (September/October 2003): 14–15.

"These Pictures Tell a Story." *Arts* 27 (September/October 2004): 14–15.

"Marc Riboud: Photographing the World, 1953–2005." *Arts* 29 (March/April 2006): 16–17.

"Highlights from the Harrison Collection of Fine Photographs, 1992–2006." *Arts* 29 (May/June 2006): 18–21.

The Harrison Collection of Fine Photographs, 1992–2006. Minneapolis: Minneapolis Institute of Arts, 2006.

"The Search to See: Photographs from the Collection of Frederick B. Scheel." *Arts* 30 (September/October 2007): 16–17.

Acknowledgments

IN WRITING THIS PUBLICATION and organizing the exhibition it accompanies, I relied upon the expertise and help of many individuals to whom I am grateful. Carroll T. (Ted) Hartwell (1933–2007), naturally, was of paramount importance, for the entire project emanates from his collecting activities as the long-serving curator of photographs at the Minneapolis Institute of Arts. I had the privilege to work with Ted since 1980, learning much about creative photography and how to negotiate cooperatively with photographers, dealers, collectors, donors, and fellow staff members. He quickly began treating me as a professional colleague, a true compliment from such a pioneer in our relatively small and young field. Eschewing paperwork, meetings, and museum politics, Ted preferred to meet with artists, look at original photographs, and talk about their meaning. He has left both the Twin Cities community and the larger photography world with the splendid legacy of a permanent collection of 10,000 photographs that reveals his critical eye and passion for humanistic, as well as artistic, imagery.

Ted built the collection with the essential assistance of generous individuals who gave funds and who donated actual pictures. Kate and Hall J. Peterson and Alfred and Ingrid Lenz Harrison contributed the most notable photography purchase funds. Those who gave photographs that are included in this catalog are: D. Thomas Bergen, Stephen Daiter, Jud and Lisa Dayton, Harry M. Drake, Walt McCarthy, Virginia P. Moe, Ralph Rapson, Frederick B. Scheel, Dan and Mary Solomon, and Lora and Martin G. Weinstein.

Over the course of Ted's extended tenure at the museum he befriended many people, including the following donors who happily supported this catalog and exhibition: Alfred and Ingrid Lenz Harrison, Elisabeth J. Dayton, Cy and Paula DeCosse through the Minneapolis Foundation, Walt McCarthy and Clara Ueland, Frederick and Virginia Scheel, Harry M. Drake, Martin and Lora Weinstein, and Myron and Anita Kunin. The catalog you hold in your hands is largely the result of the tireless efforts of three experts: Susan C. Jones, who sensitively edited my manuscript; Sam Silvio, who provided its inspired design; and Jim Bindas, who coordinated its production and printing.

At the Minneapolis Institute of Arts, I thank Kaywin Feldman, director, for supporting the project, and Emily Glaser, for her skilled administrative assistance. Charles Walbridge expertly photographed the originals for reproduction, and Patricia Landres carefully matted and framed the pieces for exhibition. I also express my appreciation to the many other devoted staff members who contributed to the success of this project.

CHRISTIAN A. PETERSON
Acting Curator of Photographs

Index

Photographic Credits

Ansel Adams: Center for Creative Photography, University of Arizona © The Ansel Adams Publishing Rights Trust

Robert Adams: © Robert Adams, courtesy Fraenkel Gallery, San Francisco, and Matthew Marks Gallery, New York

Diane Arbus: © 1970 The Estate of Diane Arbus, LLC

Richard Avedon: © 2008 The Richard Avedon Foundation

Hans Bellmer: © 2008 Artists Rights Society (ARS), New York/ADAGP, Paris

Bill Brandt: © Bill Brandt Archive Ltd.

Walker Evans: © Walker Evans Archive, The Metropolitan Museum of Art

Robert Frank: © Robert Frank, from *The Americans*

Lee Friedlander: © Lee Friedlander, courtesy Fraenkel Gallery, San Francisco

Frank W. Gohlke: © 1975 Frank W. Gohlke, courtesy Howard Greenberg Gallery, New York

Luis González Palma: © Luis González Palma, courtesy Schneider Gallery, Chicago

Philip Jones Griffiths: © Philip Jones Griffiths, courtesy Magnum Photos

Dave Heath: © Dave Heath, courtesy Howard Greenberg Gallery, New York

Man Ray: ©2008 Man Ray Trust/Artists Rights Society (ARS), New York/ADAGP, Paris

Joel Meyerowitz: © Joel Meyerowitz, courtesy Edwynn Houk Gallery, New York

László Moholy-Nagy: © 2008 Artists Rights Society (ARS), New York/VG Bild-Kunst, Bonn

Paul Outerbridge, Jr.: © 2008 G. Ray Hawkins Gallery, Los Angeles

Gordon Parks: © Gordon Parks

Arthur Rothstein: © Arthur Rothstein/Corbis

Aaron Siskind: © Aaron Siskind Foundation, courtesy Silverstein Gallery, New York

Frederick Sommer: © Frederick & Frances Sommer Foundation

Alec Soth: © Alec Soth

Alfred Stieglitz: ©2008 Georgia O'Keeffe Museum/ Artists Rights Society (ARS), New York

Paul Strand: © Aperture Foundation, Inc., Paul Strand Archive

Val Telberg: © Estate of Val Telberg, courtesy Laurence Miller Gallery, New York

Todd Webb: © Estate of Todd Webb, courtesy Evans Gallery

Edward Weston: Center for Creative Photography © 1981 Arizona Board of Regents

Minor White: Reproduced with permission of the Minor White Archive, Princeton University Art Museum. © Trustees of Princeton University